A CENTURY
OF STORIES
NEW HANOVER COUNTY PUBLIC LIBRARY
1906-2006

IMAGES
of America

TOPSAIL ISLAND

A CENTURY
OF STORIES
NEW HANOVER COUNTY PUBLIC LIBRARY
1906-2006

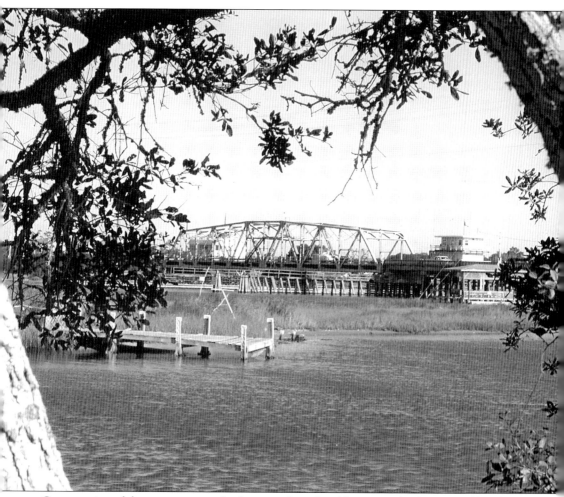

Construction of the current swing bridge to replace the old pontoon bridge was well under way when Hurricane Hazel hit in 1954. The storm ripped out the pontoon bridge from its moorings, and it had to be repaired and pulled back into place. Our swing bridge is a working antique, one of a handful still around, and a proud reminder of how far we have come and how much we love our history. (Courtesy of Jeff Conerly.)

ON THE COVER: It was 1965 when this photograph was taken at the Topsail Sound Pier. Lyndon Johnson was president. "The Girl From Ipanema" was a hit. And on Topsail Island, kids were hanging out at Warren's Soda Shop, skating at Jenkins', and fishing at a pier. Shown here are, from left to right, J. Michael Boryk with his wife, Jelynn, Irene Langdon, and her husband, Braxton. (Courtesy of the Oppegaard family.)

IMAGES
of America

TOPSAIL ISLAND

BJ Cothran

ARCADIA

Published by Arcadia Publishing
Charleston SC, Chicago IL, Portsmouth NH, San Francisco CA

Printed in the United States of America

Library of Congress Catalog Card Number: 2005938881

For all general information contact Arcadia Publishing at:
Telephone 843-853-2070
Fax 843-853-0044
E-mail sales@arcadiapublishing.com
For customer service and orders:
Toll-Free 1-888-313-2665

Visit us on the Internet at www.arcadiapublishing.com

For Jack, who loves the island as much as I do, and for Mary Grace
and her parents, Jessica and Tony, who share our love of the sea.

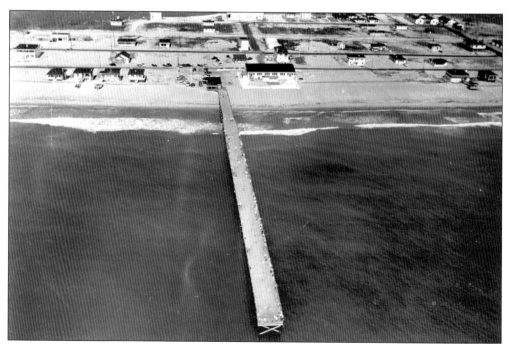

Topsail Island's love affair with fishing dates back to pre-military days. Fishermen were coming here back when they had to row over in skiffs from the mainland. With the addition of fishing piers like the Jolly Roger in Topsail Beach, shown here, fishing became more accessible for more people. (Courtesy of Phil Stevens and the Wayne Reynolds family.)

CONTENTS

ACKNOWLEDGMENTS

For those who came before me, thank you for digging deep into the wealth of history we have here on the island and for recording it for generations to come. This includes a deep admiration for the incredible work on the part of Evelyn Bradshaw and David Stallman and the dedicated few who formed the first historical society board and membership. Without those initial efforts, much of our island's history would now be lost. Thank you for the enormous support from the current historical society board for allowing me to use images from your growing collection, with special thanks to Joyce Nelson, Rose Peters, and Bill Morrison.

Other wonderful organizations and islanders opened their personal collections to me, without which the book would not have been possible. On an island, this is particularly immense, since many have only a few precious photographs that have survived the storms. But you shared generously and I thank you, with specific mention to include: Martha Alexander, Jean Beasley, Karen Beasley Rescue and Rehabilitation Center, Pat Braxton, Norman Chambliss, Howard and Melissa Comer, Jeff Conerly, Buddy Edmondson, Connie Finney, Bev Green, Bernice Guthrie, Traci Hackman, Patricia Hughey, Charles Hux, Marianne Jones Orr, Johns Hopkins University Applied Physics Laboratory, Paul and Susan Magnabosco, Sue Medlin Smith, Larilyn Swanson, Missiles and More Museum, North Carolina State Archives, Merle Morris, Onslow County Museum, Annette Oppegaard, Jo Anne Paulin, Christopher Rackley, Wayne and Michelle Reynolds, Julia Sherron, Phil Stevens, Doug Thomas, and Lisa Whitman-Grice.

Then there are those who gave of your time and talents and phenomenal skills to help take this project from a dream to reality. Thank you to my editor, Maggie Bullwinkel, for your support and guidance. Dan Hackman, you are a genius on the computer as well as a beautiful photographer. Haywood Smith, my wonderful critique partner and friend, your input was invaluable. Linda and Dave Stipe, you stepped in wherever needed. By the Beach Realty, thank you for allowing me to take over your office and use all of your equipment. Finally, to my family and husband, Jack, thank you for your encouragement and love, not just for now, but always.

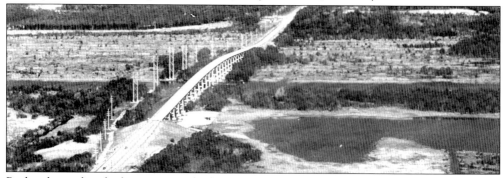

Bridges have played a large part in the history of Topsail Island. When the wooden bridge was replaced with the high-rise bridge shown here, it seemed modern technology had arrived. The impressive bridge spans the Intracoastal Waterway, connecting Sneads Ferry to North Topsail Beach. Entering the island at the top of the bridge offers a spectacular panoramic view that will take your breath away. (Courtesy of Bev Green.)

INTRODUCTION

Topsail Island's history dates back to the 18th century, when Tucscarora Indians made hunting trips to the island, and archeological evidence suggests that Permuda Island may have been the site of a seasonal encampment of prehistoric Native Americans as early as 300 BC. Arrowheads and potshards can still be spotted in the sand or marshlands surrounding the island.

Notorious pirates such as Blackbeard and Stede Bonnet roamed the waters of North Carolina regularly, so it is entirely possible these same inlets were used by pirates in the 17th and 18th centuries. Local legend is that pirate ships hid behind the island waiting to prey on passing merchant ships in the Atlantic. After a while, the freighters became wise to the ploy and started watching for the tops of the pirate's sails over the dunes, hence the name Topsail, pronounced Top-sul. Maps dating back to 1774 list New Topsail Inlet and Topsail Sound by name, so the folklore of watching for topsails is a plausible explanation for how the name Topsail came to be used. But the fact remains that it was never recorded, so the Topsail legend will remain a great reminder that pirates were here but probably passed us by without so much as a written name.

Until 1947, the island was called other names, including the not-so-elegant Sand Spit, Ashe Island, Long Island (which was logical since the island is 26 miles long), and Sears Landing. A staunch supporter of the island, attorney, entrepreneur, and former mayor of Wilmington, Edgar Yow did much to organize and develop the island in the early days. On one of his many meetings to get the job done, he and the others in attendance declared the name of the island to be Topsail. Finally it was official, and this time, it was written down.

In the 1940s, World War II brought Camp Davis to the tiny hamlet of nearby Holly Ridge, and Topsail Island was changed forever. Prior to the tens of thousands of military personnel moving into the area almost overnight, there were no settlements on the island, only fishermen who came by boat to set up fishing camps or hunting lodges. The beach had such little appeal during those early years that farmers ran their cattle across from the mainland to use Topsail as grazing land.

The strands of history are much longer in the tiny fishing village of Lower Ferry, later renamed Sneads Ferry, located off the northern end of the island on the New River. It was settled around 1775, making it the oldest established community in Onslow County, which itself was established in 1734, making it one of the oldest counties in North Carolina. The ferry was a key part of the community until 1939, when it was replaced with a wooden bridge.

Things changed for the rest of the island after the war. Operation Bumblebee came to town and brought with it the navy and Johns Hopkins University Applied Physics Laboratory. The virtually isolated and sparsely populated island was taken over by the government and turned into a secret test site for guided missiles. About 200 experimental missiles were launched here, proving the success of the ramjet engine. When Operation Bumblebee ended in 1948, the military left behind the beginnings of civilization: electricity, wells, and roads, not to mention the Assembly Building, photographic towers, and a fully operational pontoon bridge. As rickety and difficult as the bridge was reported to be, it still opened the doors to the island, doors that have been flung wide, welcoming newcomers to our shores ever since.

Land that was seized for Operation Bumblebee was returned to the owners or sold. Surf City was incorporated in 1949, followed by Topsail Beach in 1963 and North Topsail Beach in 1990. Residential developments popped up all over the island, bringing with them the need for businesses

and services. Visionaries like J. G. Anderson Sr., Lewis Orr Sr., and many other founding fathers and mothers forged ahead and built communities that have woven together to make a patchwork of neighbors who keep returning to Topsail's shores generation after generation.

And then there were the hurricanes, so many that the names all blur together save for the "big one," Hurricane Hazel in 1954, which practically demolished everything on the island, leveling houses and tossing belongings into the sea. But islanders—true islanders—build back and see the hurricanes as a necessary evil to endure to enjoy life by the sea.

Last but not least, Topsail has its own gold story, not about pirates or buried treasures, but about a shipwreck off the coast filled with a fortune in pieces of eight. A well-known group of wealthy prospectors came to the island and set up an elaborate and expensive excavation, digging for gold for several years, only to disappear overnight with no explanation, and maybe no gold. Or maybe they disappeared and the explanation is that they did find gold. The mystery remains.

Piecing together the island's history is an ongoing process. This book is but a beginning. The people and places shown here are representative of people and places all over the island that have touched us throughout the years. I enjoy hearing about Topsail, so if you have additional stories or photographs to share, please contact me at publisher@topsailmagazine.com.

The real treasure of Topsail is the island and its people. We are all rich here.

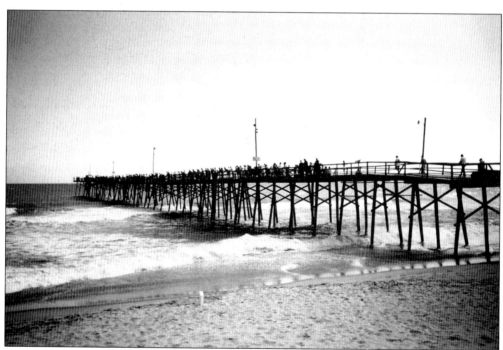

A packed fishing pier with plenty of fish to go around is a common sight all up and down Topsail Island. Fishing piers have been built and rebuilt, added onto, and destroyed. But when "the spots are running," people come from miles around to catch their fill and enjoy the camaraderie of being together doing something they love. (Courtesy of the Medlin family.)

One

TOPSAIL TURTLES

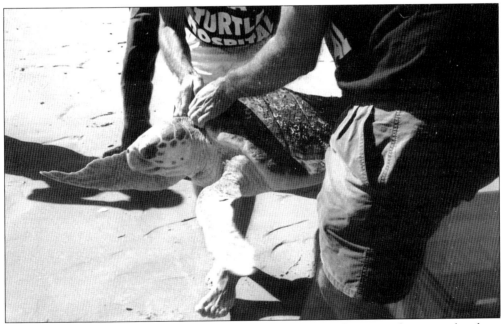

Long before the cottages and piers, long before Topsail even had a name, the sea turtles chose the dunes of this island for their birthing grounds. Perhaps for centuries, these huge sea creatures have been laying eggs and returning to our shores in an age-old cycle of life. What began as the dream of a few volunteers has now blossomed to help countless sick or injured sea turtles, not to mention thousands of baby turtles who got a head start in life under the watchful eyes of loving caregivers. Over the years, the turtle hospital has released over 160 turtles back to the sea. The final journey begins by loading up the turtles into truck beds. This takes lots of hands, since some of the turtles weigh nearly 400 pounds. Volunteers take one last ride with the turtles from the hospital to a beach location for the release. Here a happy, healthy sea turtle is returned to its watery home. (Courtesy of Karen Beasley Sea Turtle Rescue and Rehabilitation Center.)

Karen Beasley dreamed of finding a way to help the endangered sea turtles. Her vision became the Topsail Turtle Project, where numerous volunteers walked the beaches, staked and sat nests, and supervised hatchings. After Karen's death in 1991, her mother, Jean Beasley, carried the torch forward, and the project grew into the Karen Beasley Sea Turtle Rescue and Rehabilitation Center. (Courtesy of Karen Beasley Sea Turtle Rescue and Rehabilitation Center.)

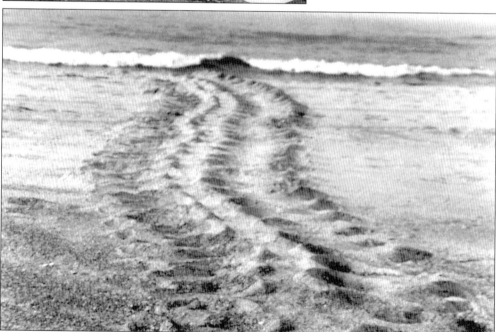

A female loggerhead digs a hole, lays an average of 120 eggs, and covers them with sand. She will come back two to five times in a nesting season, and then she takes a break for three to five years. New hatchlings are also innately programmed to return in 20 or 30 years to their natal area to lay their eggs. (Courtesy of Karen Beasley Sea Turtle Rescue and Rehabilitation Center.)

This expansive figure-eight path was made by a female sea turtle, although most tracks are parallel and look like bulldozer tracks (see opposite page). Eggs are generally laid at night, which is why it is important that beachfront lights are turtle friendly or completely off. Turtles follow the moonlight back into the ocean after laying eggs, and bright lights distract and disorient them. (Courtesy of Dr. and Mrs. Howard Braxton.)

Members of the "turtle team" volunteer countless hours walking the beaches each morning. When they find a nest, they report it, and then trained volunteers mark and cordon it off. Turtle eggs incubate for approximately 60 days. Once the hatching appears imminent, volunteer nest-sitters like Emma and Curtis Thomson keep watch over the nest until it hatches out. (Courtesy of Karen Beasley Sea Turtle Rescue and Rehabilitation Center.)

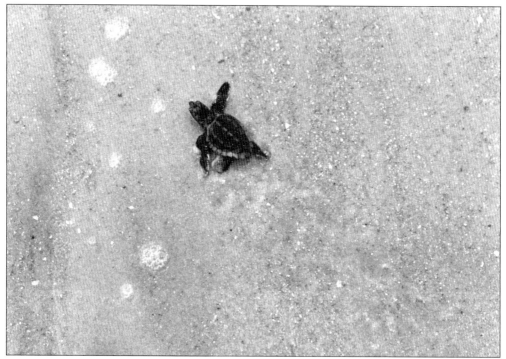

This hatchling dug his way up from the secure hole to the surface of the sand. The journey between nest and sea is perilous because of predators such as crabs and seagulls. Volunteers clear the path, count the turtles as they bubble out, and wade into the water with a large light to encourage the turtles in the right direction. (Courtesy of Karen Beasley Sea Turtle Rescue and Rehabilitation Center.)

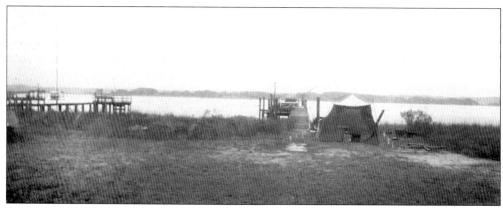

The first turtle hospital was a far cry from the modern facility seen today. This tranquil setting on the sound, owned by Howard Malpass, was the site of the first hospital, minus the tent, which was later added, making it the first hospital "building." Malpass, a founding board member, helped the turtle project move into its rescue and rehabilitation role. (Courtesy of Karen Beasley Sea Turtle Rescue and Rehabilitation Center.)

The turtle hospital was a no-frills operation in the beginning, and it still is, but ingenuity and hard work got the project off the ground. Here is volunteer Howard Malpass with what was lovingly called the first turtle ambulance, a well-used wheelbarrow. Fueled by man-power—usually Howard's—turtles were transported to his garage by "ambulance," where they received medical attention. (Courtesy of Karen Beasley Sea Turtle Rescue and Rehabilitation Center.)

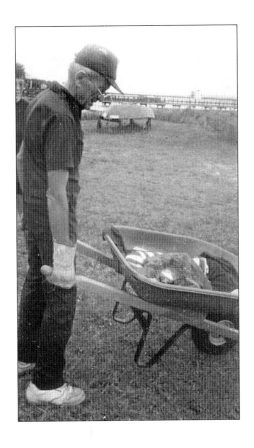

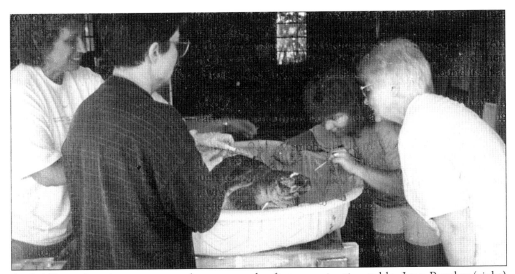

A child's pool sitting on two sawhorses was the first examination table. Jean Beasley (right) supervises cleaning a wound. The first patient was named Lucky because it was lucky to have survived a serious head injury. Turtles are now given names often related to where they were found, such as Swan, found near Swansboro, and Myrtle near Myrtle Beach. (Courtesy of Karen Beasley Sea Turtle Rescue and Rehabilitation Center.)

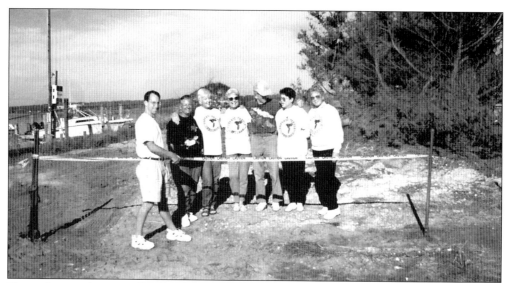

Shown here at the groundbreaking ceremony for the new home of the Karen Beasley Sea Turtle Rescue and Rehabilitation Center are, from left to right, Topsail Beach town manager Eric Peterson, Sandy Sly, Director Jean Beasley, Emma Thomson, Howard Malpass, Sharon Dermott, and Bev Green. These are some of the people instrumental in taking a dream and making it a reality. (Courtesy of Karen Beasley Sea Turtle Rescue and Rehabilitation Center.)

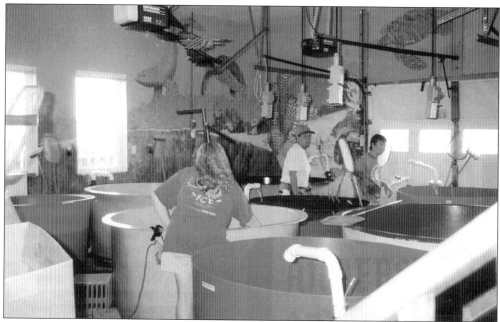

From one lonely tent, the turtle hospital grew to its present-day location behind town hall. The center leased the land from Topsail Beach for $1 a year and raised the funds to build the hospital and purchase equipment, including the large tanks shown here. The hospital is solely supported by donations and fund-raising activities by its volunteers. (Courtesy of Karen Beasley Sea Turtle Rescue and Rehabilitation Center.)

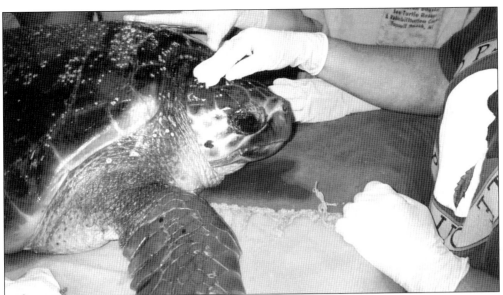

Once its initial trauma is treated, a sick or injured turtle sometimes takes months, even years, to recover. Daily care provided by dedicated volunteers includes cleaning wounds and administering medications as well as feeding and maintaining the tanks. Turtle "patients" may include gigantic loggerheads (scientific name *Caretta caretta*), rare Kemp's Ridley turtles (*Lepidochelys kempi*), and even occasional Atlantic green sea turtles (*Chelonia mydas*). (Courtesy of Karen Beasley Sea Turtle Rescue and Rehabilitation Center.)

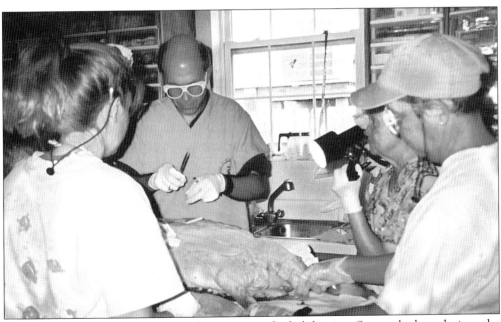

A big part of the turtle program involves rescue and rehabilitation. Sea turtles brought into the hospital are either sick or injured by boat propellers or fishing nets. Medical attention is provided by the hospital, including on-site surgery. Here one of the many volunteer veterinarians performs surgery. Jean Beasley (second from right) assists with the lighting as interns and volunteers observe. (Courtesy of Karen Beasley Sea Turtle Rescue and Rehabilitation Center.)

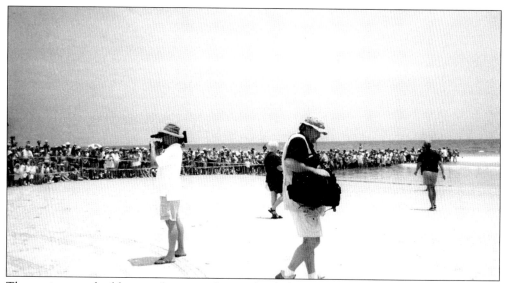

The excitement builds as each sea turtle is unloaded and carried into the water. Crowds of spectators line the roped-off runway for a glimpse of these beautiful creatures as they splash out to sea. For years, the turtle hospital has expanded its outreach program to allow bus after bus of schoolchildren to tour the hospital and witness releases. (Courtesy of Karen Beasley Sea Turtle Rescue and Rehabilitation Center.)

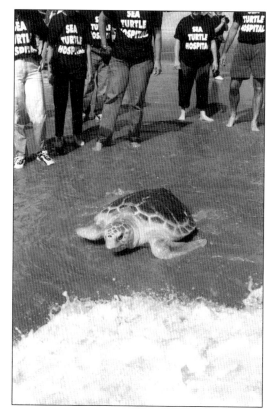

Volunteers say a bittersweet goodbye. Sea turtles were once slaughtered for meat, and eggs were prized for making soup. Due to the addition of man-made dangers, all species of sea turtles are protected by the Endangered and Threatened Species Act. It is a nice symmetry that Topsail is now part of the solution to bring sea turtles back from near extinction. (Courtesy of Karen Beasley Sea Turtle Rescue and Rehabilitation Center.)

Two

OPERATION BUMBLEBEE

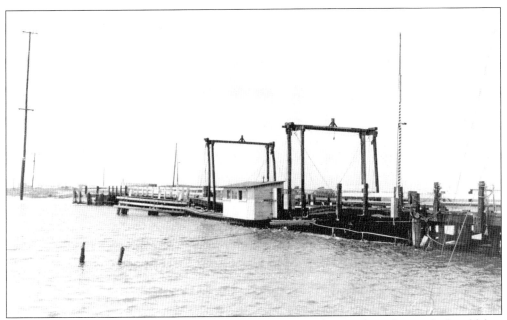

"THE BUMBLEBEE CANNOT FLY. According to recognized aerotechnical tests, the bumblebee cannot fly because of the shape and weight of his body in relation to the total wing area. But, the bumblebee doesn't know this, so he goes ahead and flies anyway." When Dr. Merle Tuve saw those words hanging on the office wall of Capt. Carroll L. Tyler, U.S. Navy, special assistant to the Director of the Office of Scientific Research and Development (OSRD) in December 1944, he proclaimed the code name of the navy's newest undertaking Operation Bumblebee, a secret government project by the navy's Bureau of Ordinance in conjunction with the Applied Physics Laboratory of Johns Hopkins University. Because of the mission's immense obstacles in developing a supersonic guided missile, the endeavor was likened to the bumblebee that succeeds in flying against all odds. The Sears Landing pontoon bridge was the sole link to the island from the mainland, making it the key to access and availability for equipment and personnel. (Courtesy of Johns Hopkins University Applied Physics Laboratory [JHU/APL].)

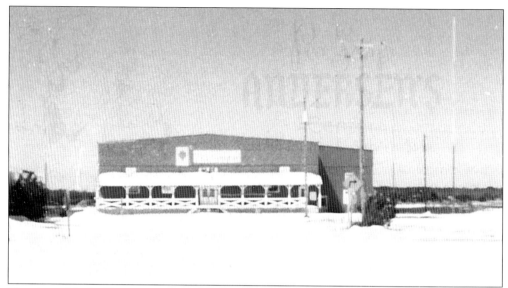

The Assembly Building was constructed for assembly and storage of rockets. Built to minimize explosions, the building has thick, reinforced walls, four feet of concrete in the foundation, 20-foot pilings, and lightning rods at each corner. Over the years, it has remained relatively unchanged. Shown in March 1980, when it was Caison Brothers Supply Company, it is covered with an island rarity, a dusting of snow. (Courtesy of Dr. and Mrs. Howard Braxton.)

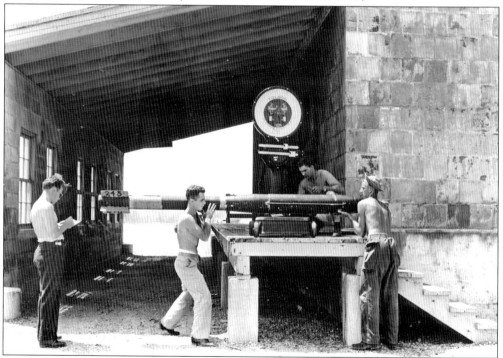

The ramjet was fashioned from the tailpipe of a navy Thunderbolt airplane. Nicknamed the "flying stovepipe" because it was virtually hollow inside like a stovepipe, the experimental rockets were 3–13 inches in diameter and 3–13 feet in length. This rocket was being weighed on a Toledo scale in an area at the back of the Assembly Building. (Courtesy of JHU/APL.)

Booster rockets are solid fuel rockets that are designed to boost the missile off the launch platform. Once in flight, the ramjet is supposed to kick in and take off. The booster gets the ramjet off the ground so it can perform at optimum capacity. This basic premise is what they were attempting to prove with Operation Bumblebee, and they did so with great success. (Courtesy of JHU/APL.)

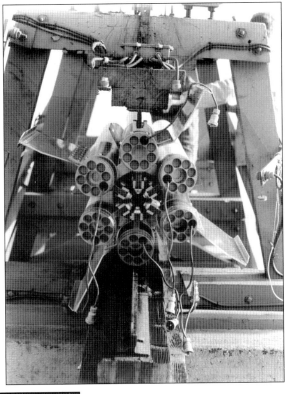

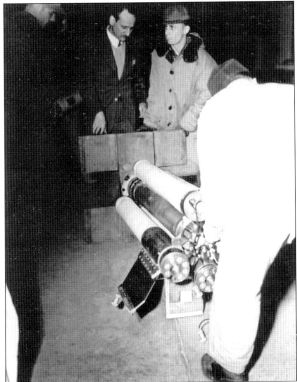

Crates of missile parts were shipped by railroad to Wilmington, North Carolina, from the Johns Hopkins location in Silver Springs, Maryland. Security was tight, not only around the mission itself but around the shipments, too. Research and development took place in Maryland, so the components that were shipped were guarded throughout the trip, including the last leg from Wilmington to Topsail. (Courtesy of JHU/APL.)

19

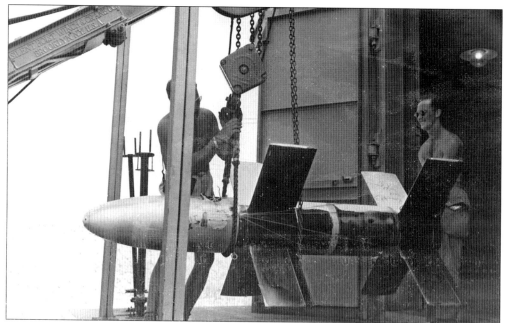

During World War II, the success of Japanese kamikaze air attacks convinced the navy of the need for an improved air defense system that could destroy enemy planes before they could get within striking distance of our ships. On firing day, the solid propellant was loaded into the missile, and then the missile was carefully moved from the Assembly Building to the launching pad. (Courtesy of JHU/APL.)

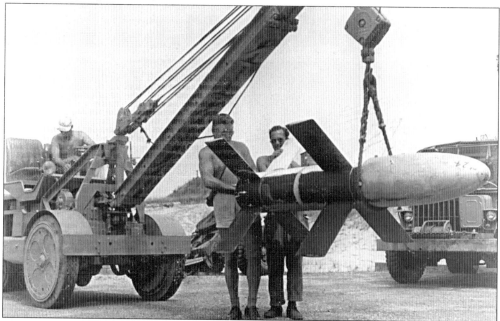

The distance from the Assembly Building on the sound, across the width of the island, to the concrete launching pad on the beach was a short but perilous trip when carrying a missile ready for firing. Various methods of transportation were used to carry missiles, including a rubber-tired dolly, jeep, and crane. (Courtesy of JHU/APL.)

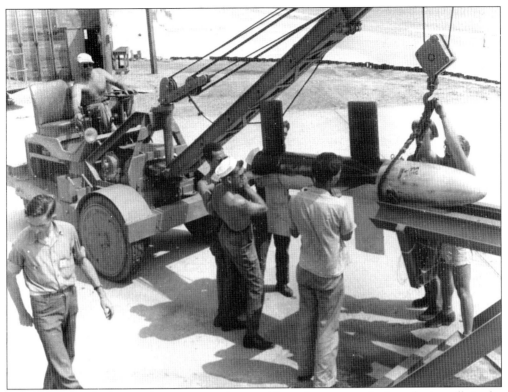

Once at the beach, the missile was cautiously moved from the crane to the launcher's cradle in the launcher. One of the amazing accomplishments of Operation Bumblebee is that they developed an engine with no moving parts that weighed around 70 pounds and attained supersonic speeds from zero to 1,500 miles per hour in a matter of seconds. (Courtesy of JHU/APL.).

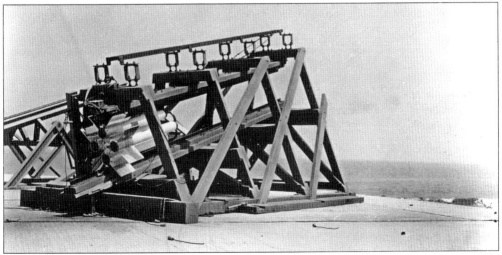

The launchers were wooden structures with steel half-casings of different sizes up to approximately 15 feet long. Launchers were set at various angles to accommodate the desired trajectory. The launcher is sitting on a concrete platform a foot thick measuring 75 feet by 100 feet. The navy's first operational supersonic missiles—Terrier and Talos—grew out of those launched from these crudely constructed ramps. (Courtesy of JHU/APL.)

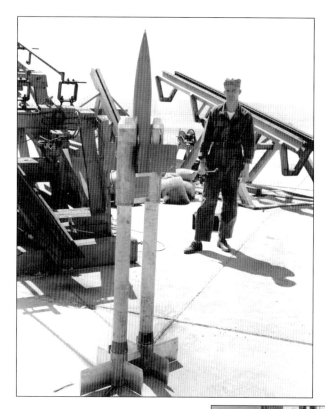

Many of the experimental firings of the ramjet occurred on this concrete launching pad, now the patio for the Jolly Roger Motel and Pier in Topsail Beach, between 1946 and 1947. The navy stayed well ahead of the army in the development of the stovepipe, as the army did not successfully test fire a similar missile until May 1947. (Courtesy of JHU/APL.)

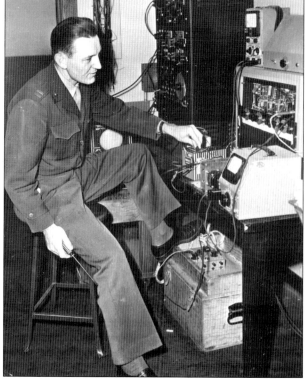

Captain Haigler of Waxhaw, North Carolina, was probably operating equipment in the control tower located on a line halfway between the Assembly Building and the launching platform. From the control tower, there was two-way communication with the photographic towers, where data on the missile firings was recorded. (Courtesy of JHU/APL.)

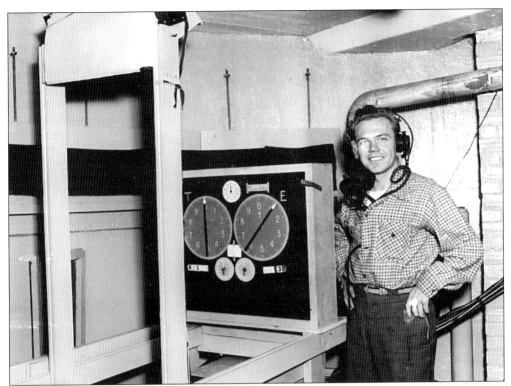

Located at the launching site, the bombproof room was accessed through a heavy steel sliding door. Built for safety, the reinforced concrete walls were 14 inches thick. Firings could be observed at close range by rocket scientists and technicians through a four-inch-by-three-foot window slit. Harold Dail of Kinston, North Carolina, collected data and tracked firings from his position in the bombproof room. (Courtesy of JHU/APL.)

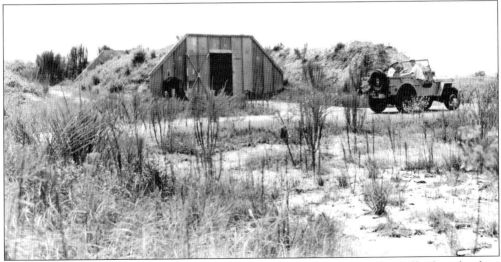

At the south end of the island was a bunker used to house munitions. Typically these bunkers would be utilized to store weapons and ammunition used in war, but for Operation Bumblebee, it possibly stored the rocket fuel a safe distance from the Assembly Building. This bunker did not survive over the years. (Courtesy of JHU/APL.)

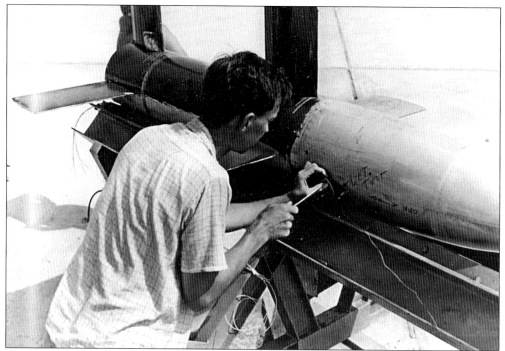

Once the missile was placed in the launcher at the concrete launch pad on the beach, the checkout process would begin. If any step in the checkout didn't meet appropriate standards, the firing would be cancelled and the missile would be carefully returned to the Assembly Building. When returned at this stage, extra security precautions would go into effect. (Courtesy of JHU/APL.)

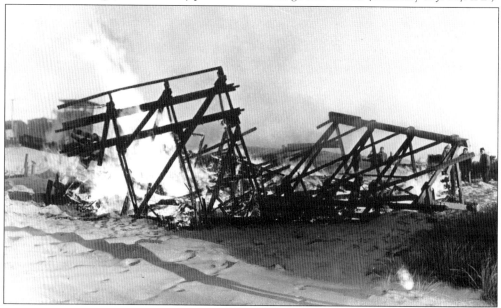

The missile firings were experimental in nature and, as such, unpredictable. Rockets did go off course, even though safety precautions were in place and every effort was made to avoid accidents and crashes. When experiments and explosives combine, fire is always a potential threat, as seen here. (Courtesy of JHU/APL.)

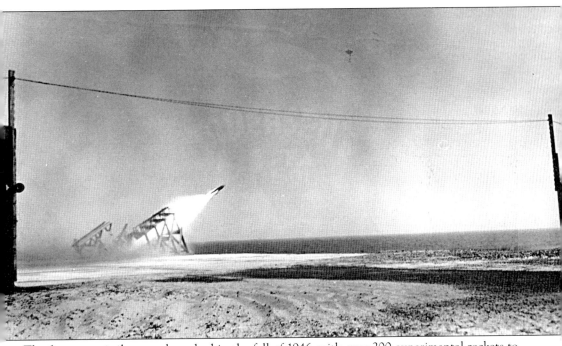

The first test missiles were launched in the fall of 1946, with over 200 experimental rockets to follow until 1948, when Operation Bumblebee came to an end. Even though much had been accomplished, increased ship traffic and a growing population nearby made the site less desirable than it had been in the beginning. Despite the fact that the site on Topsail Island was designed to be a permanent installation, and much time and effort and resources had gone into the effort, the weather was not conducive to good instrumentation. Other sites were studied and determined to be better suited for the next stage of the program, so the project was dismantled and distributed to Stewart, Florida (Cape Canaveral/Kennedy); Inyokern, California; and White Sands, New Mexico. Much of the site facilities were left intact, and the island inherited what have become beloved landmarks of history. (Courtesy of JHU/APL.)

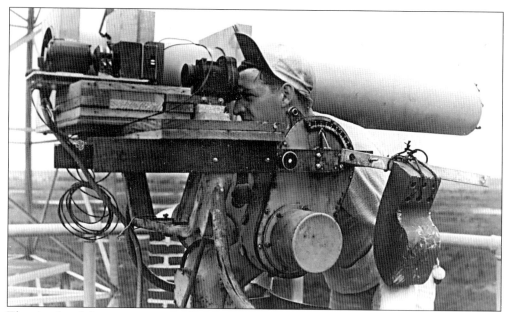

The cinetheodolite system was used to measure the velocity and acceleration of the supersonic guided missiles. From the towers, flights were tracked using dual 16-mm cameras. The equipment was designed for Mach numbers to five (five times the speed of sound), maximum altitudes of 60,000 feet, and ranges up to 80,000 yards, or from 10 to 20 miles. (Courtesy of JHU/APL.)

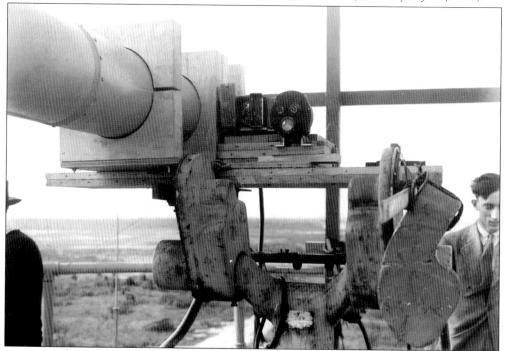

The photographic equipment was mounted on a steering device probably based on a Mk 51 gun director scavenged from a navy warship and modified with the simple resources available locally. Heavy scraps were attached as counterweights, allowing the cameraman to rapidly pan and tilt the device to follow the missiles and capture the images. (Courtesy of JHU/APL.)

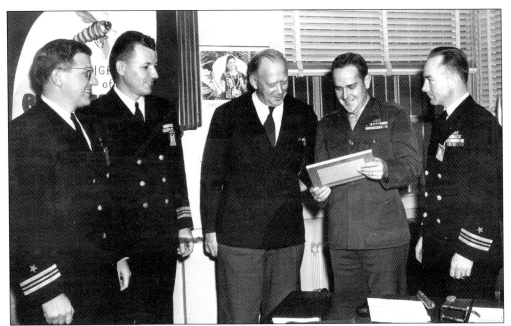

A few years after Operation Bumblebee, Lt. Comdr. Tad Stanwick was invited to Washington, D.C., and to his surprise, was asked to tell high-level military officials about his experiences at Topsail. Some of the attendees were, from left to right, Lt. Comdr. Tad Stanwick, Lt. Comdr. E. A. Sandor, Dr. R. E. Gibson, Lt. Col. J. O. Bell, and Lt. Comdr. A. G. Hamilton Jr. Notice the bumblebee on the chart. (Courtesy of Missiles and More Museum and Tad Stanwick.)

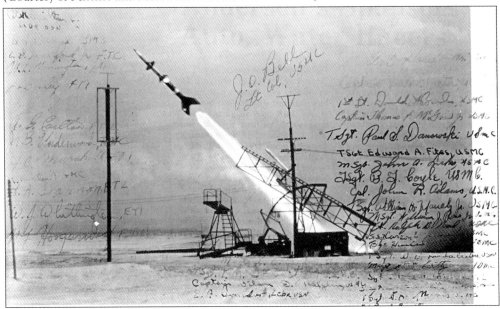

Lt. Comdr. Tad Stanwick, officer in charge of the Naval Ordinance Development Unit, played a major role in the construction of the Topsail facilities, including the towers that still dot the island's landscape. The original photograph filled with signatures reads "To: Commander Stanwick and the Staff of NODU/APL/JHU. From: The Officers and Men of the First Marine and Navy TERRIER Guided Missile Units." (Courtesy of Missiles and More Museum and Tad Stanwick.)

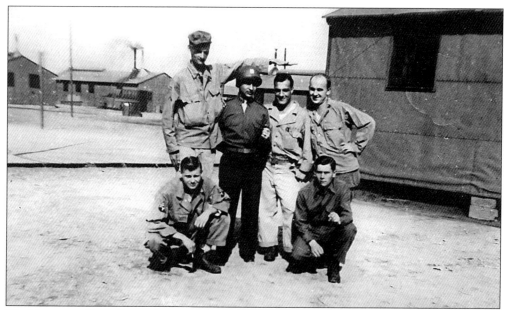

Work began on Camp Davis, the army's first anti-aircraft artillery training facility, in late December 1940, and was completed in an incredible five months. The entire installation in the Holly Ridge area included Topsail Island and covered more than 44,000 leased acres. Sgt. Benjamin Paul Marcianti, second from left, is shown here with other unidentified servicemen who served at Camp Davis prior to its closing in September 1944. (Courtesy of Jo Anne Paulin.)

Camp Davis was named for prominent North Carolina veteran Maj. Gen. Richmond Davis, who started his illustrious career after graduating from West Point in 1887. Used as an army training base and the site of the first Barrage Balloon Training Center, and later by the Marines and as a separation center, it finally became, in part, living quarters for families of men working on Bumblebee. (Courtesy of Missiles and More Museum.)

Harold Dail, shown in the bombproof room pictured on page 23, shared these living quarters with his wife while he worked on the Bumblebee project. At its peak capacity in 1943, Camp Davis housed more than 110,000 military personnel, but during the time it was the navy's Bumblebee program's base, only around 500 people lived on site. (Courtesy of Missiles and More Museum.)

The first missile test range was located at Island Beach, New Jersey, in 1945, then moved to Rehoboth Beach, Delaware, and finally to Topsail Island in 1946. Harold Dail, center row at left, is shown with his coworkers on Island Beach prior to several of them moving to Topsail. (Courtesy of Missiles and More Museum.)

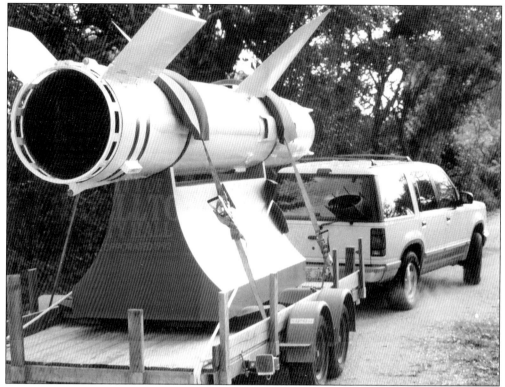

Two longtime historical society members, William Morrison and Charles Bryan, drove to Maryland to transport a refurbished Talos to its new Topsail home. To avoid any more attention than a rocket going down the highway on a boat trailer naturally causes, they covered the rocket. Just in case they were stopped, they carried letters from the Topsail police and historical society explaining what they were doing. (Courtesy of Missiles and More Museum.)

Over 50 years after Operation Bumblebee began, the Talos, a legacy of the missile testing that began here on the island, is now displayed in front of the building where rockets were first assembled. Celebrating the occasion is a gathering of historical society members. The Talos rocket was donated by the Johns Hopkins University Applied Physics Laboratory. (Courtesy of Missiles and More Museum.)

Three

THE TOWERS

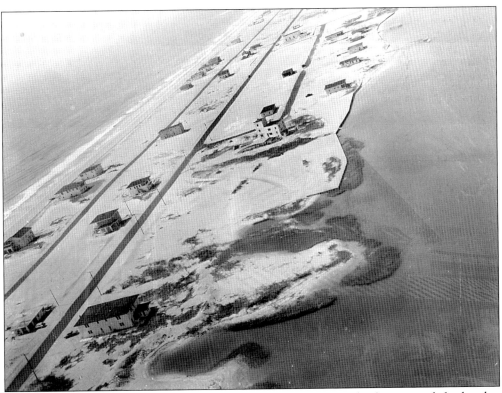

Operation Bumblebee was shrouded in secrecy and buried in unopened military records for decades. The photographic towers were an integral part of the mission. They were precisely located at points scientifically derived for optimum recording. In each tower, a cinetheodolite camera was zeroed in on the next tower to synchronize and record telemetered data. This aerial view of Topsail Beach shows a southern shot of the island in the area of Hines Avenue, where Tower Number One is easy to spot on the sound. This tower was featured on a Home and Garden Television show about unusual homes. (Courtesy of Phil Stevens and the Wayne Reynolds family.)

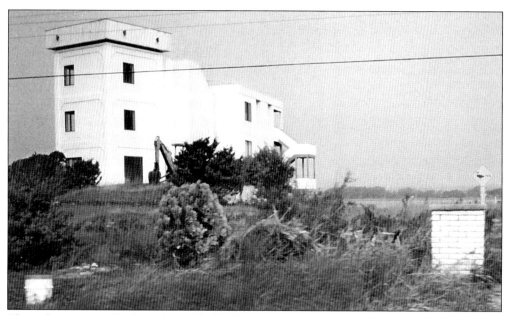

The only tower south of the Assembly Building is Tower Number One, located sound side on Hines Avenue. The tower was first converted into a home by the Bordeaux family in 1949. Later owners Taye and Lloyd Bost took the architecture of the tower into consideration and built onto theirs, so that it is hard to tell what was original and what was added. (Courtesy of Dr. and Mrs. Howard Braxton.)

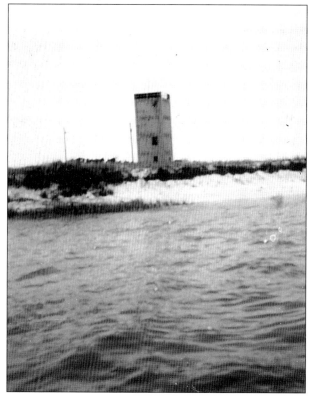

Tower Number Two is located sound side at Queen's Grant Condominiums. In 1993, the tower was placed on the National Register of Historic Places, along with the Assembly Building and the control tower. This tower was chosen because it is the tower that best represents the look of the original towers in 1946. Today a seawall has been constructed on the sound in this location. (Courtesy of Dr. and Mrs. Howard Braxton.)

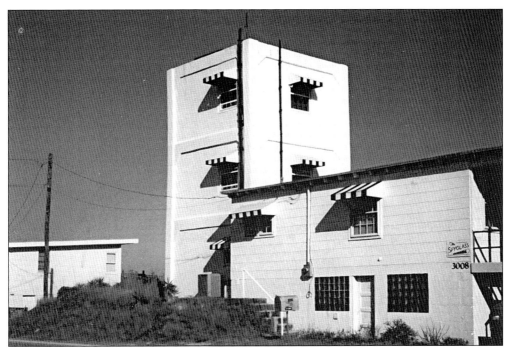

Judge John Thomas Bland was an early owner of Tower Number Three. His heirs converted it into a home in 1950 with a comfortable addition. In 1965, Kenyon and Evelyn Ottoway traded property to acquire the tower. Evelyn loved music, and it is interesting to note that her father played with John Philip Souza. (Courtesy of Missiles and More Museum.)

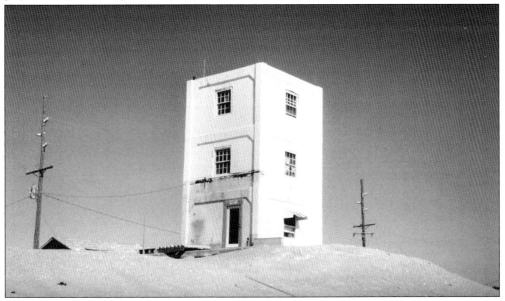

Tower Number Three, near the town line between Surf City and Topsail Beach, is the third of eight photographic towers for Operation Bumblebee. In September 1996, this view shows how Hurricane Fran totally demolished everything but the tower. The Gresham family now owns the tower, which sits alone in a quiet stretch of beach and has remained virtually untouched since Fran. (Courtesy of Missiles and More Museum.)

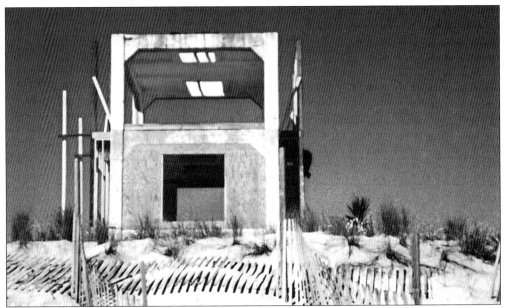

Located near what is called the S-curve in Surf City going south toward Topsail Beach is what was left of Tower Number Four. For decades, visitors and locals incorrectly speculated that the towers were built during World War II and used for observing possible German submarine activity off the North Carolina coast. (Courtesy of Missiles and More Museum.)

Maintaining the basic structure and shape of the original tower, but not the stark white color, Tower Number Four is nestled in a row of beautiful beach homes in Surf City. Standing out only as a lovely, well-landscaped home, a passing driver might never know its true place as a piece of aeronautical and island history. (Courtesy of Missiles and More Museum.)

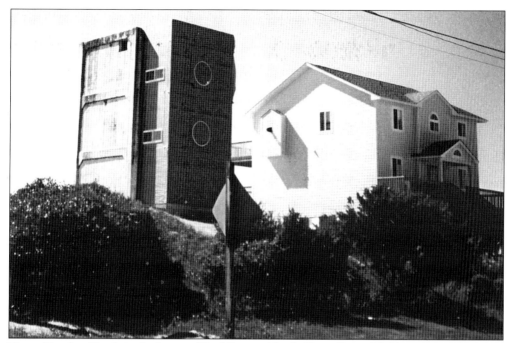

Tower Number Five is in the heart of Surf City on North Shore Drive. Unlike some additions on other towers, this renovation encompasses all three stories. In each subsequent transformation, the original structure was left evident from the beach and sides. The original white tower is easy to spot in this photograph, even with the matching addition. (Courtesy of Missiles and More Museum.)

Owner Ken Richardson turned the fifth tower from Operation Bumblebee on the island into a magnificent beach home, once described as possibly the tallest home on the island because of an added penthouse on the top of the original structure. During the Bumblebee days, the photographic towers sported flat tops surrounded by railings, the perfect setting for observing and recording data. (Courtesy of Missiles and More Museum.)

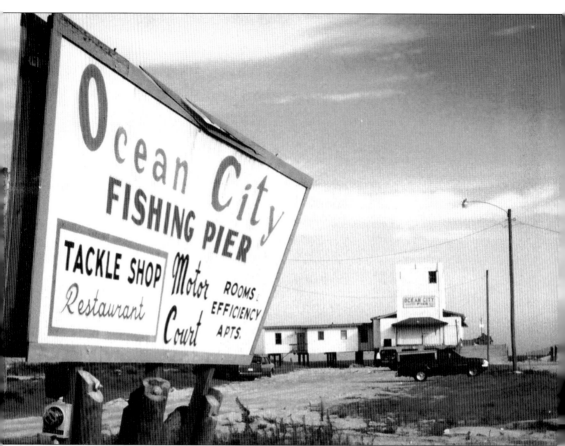

It all began with local attorney and business owner Edgar Yow, who had a vision for Topsail Island in its infancy. Using his contacts from when he was mayor of Wilmington, North Carolina, in the early 1940s, he saw a way to solve the shortage of building materials after World War II with a plan to reuse buildings, piping, and other salvageable materials from the closed Camp Davis. In addition to supervising the disposition of the property, he was instrumental in setting up the waterworks for what would become Surf City. He also drew up the Surf City Charter of Incorporation and named David Lucas the first mayor. His next challenge was to provide the opportunity for African Americans to own beach property, a radical idea in 1949, since racial segregation was still the norm. An interracial corporation, Ocean City Developers, was formed with the Chestnut brothers—Bertram, Wade, and Robert—who owned an automobile repair business in Wilmington. (Courtesy of Missiles and More Museum.)

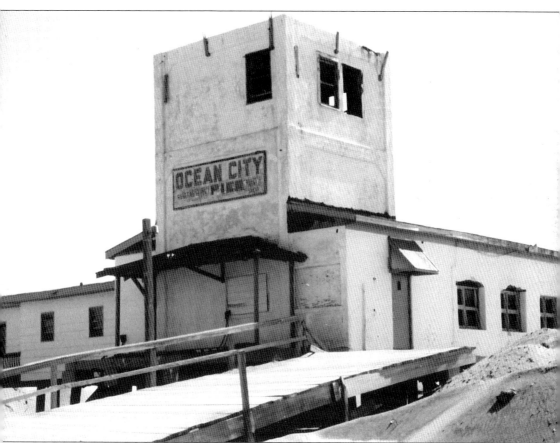

More than half a century ago, Ocean City was established as one of North Carolina's first minority beachfront communities. Wade and Caronell Chestnut were instrumental in the development and success of Ocean City, about three miles north of Surf City stretching from beach to sound and begun with a piece of property owned by Edgar Yow. In the 1950s, Tower Number Six was turned into a tackle shop and restaurant. Hurricane Hazel hit in 1954, taking out many of the cottages, but the owners repaired or started over. The tower became the pier house when the Ocean City Pier was built in 1959. The pier and buildings were hard hit by the storms of the 1990s, closing the operation for good after Hurricanes Bertha and Fran in 1996. In 1990, North Topsail Beach was incorporated, including Ocean City. Alternating talks of demolition and renovation have occurred since then, and a Georgia company now owns the pier property and tower, but as of 2006, nothing has changed since those hurricanes. (Courtesy of Missiles and More Museum.)

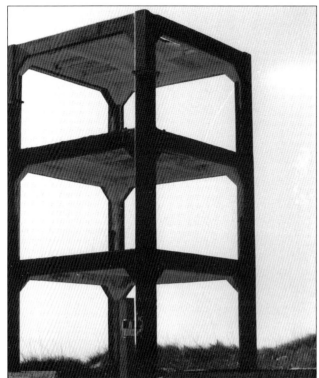

After Operation Bumblebee, many of the towers became empty shells, stocky skeletons stretching into the air. Tower Number Seven was once one of those three-story shells perched oceanside in a less-populated area near Rogers Bay Campground on Island Drive in what is now North Topsail Beach. (Courtesy of Bev Green.)

Possibly the most difficult tower to spot on the island, Tower Number Seven has been completely enclosed in a lovely oceanfront home. Even though the hardened structure isn't readily visible, the heart of the home is still a tribute to Topsail's military glory and scientific achievements. Tower Number Seven is one of three towers located in Onslow County, while the other four are in Pender County. (Courtesy of Missiles and More Museum.)

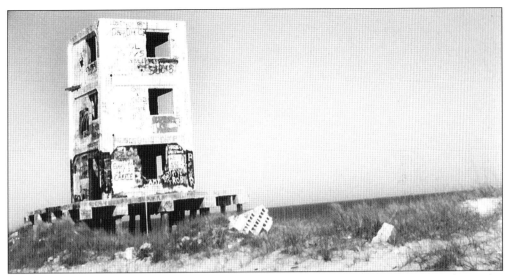

Time and Mother Nature were not kind to all of the towers, particularly Tower Number Eight, known as the Jeffreys Tower after owner George Jeffreys. Between vandals, trespassers, and storms, the northernmost tower was ill-fated and ultimately destroyed by its last owner, Marlo Bostic. It is sad to think that a part of Topsail's illustrious history is now crowding a landfill, but that is the tower's final resting place. (Courtesy of Missiles and More Museum.)

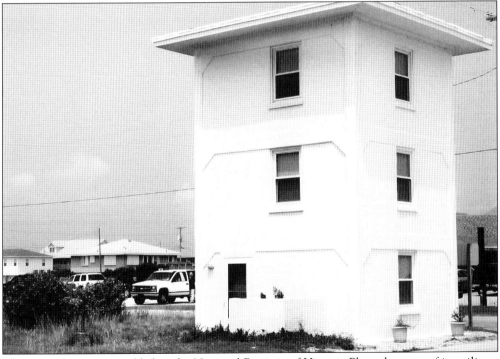

The control tower was added to the National Register of Historic Places because of its military significance. Established in 1966, the register is the nation's official list of buildings, structures, objects, sites, and districts worthy of preservation for their significance in American history, architecture, archaeology, and culture. The places listed reveal in a tangible way some important aspect of past life in North Carolina. (Courtesy of Missiles and More Museum.)

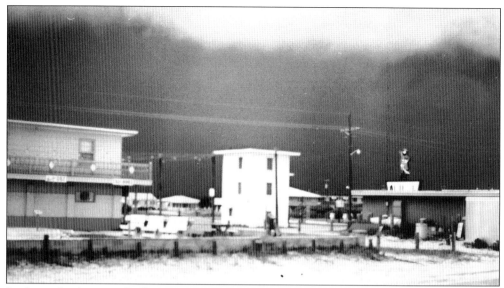

In this early photograph, the Firing Point Control Tower sits at the midway mark between the Assembly Building and the launching pad on the beach, just as it did in the late 1940s. During Operation Bumblebee, this tower was a lone sentinel housing the two-way communication equipment that connected the control tower with the photographic towers lining the coast. (Courtesy of Charles Hux.)

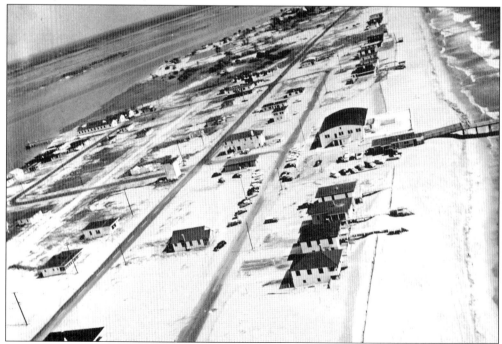

Several of the Operation Bumblebee relics are easy to pick out in this aerial photograph taken during the 1950s. To the far right, about midway up the picture, is the Jolly Roger Pier with the launch pad in clear view. On the far left, you can spot the Breez-Way Inn, converted from old barracks. A little off-center is the easily recognized control tower. (Courtesy of Phil Stevens and the Wayne Reynolds family.)

Four

MISSILES AND MORE MUSEUM

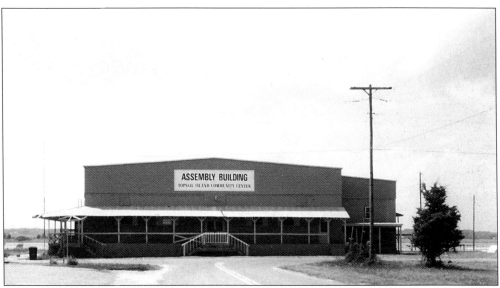

Home to the Missiles and More Museum, the Assembly Building has reinvented itself many times in the past 50 years. The building seems to have come full circle, beginning life as a place constructed solely for the purpose of assembling rockets and now a museum celebrating that period in our nation's history, as well as our local heritage. The museum opened its doors to the public on April Fool's Day in 1995. Those members who were involved with the initial efforts have described the displays as looking like a "garage sale." Photographs were attached to pink lattice with clothespins. Over the past decade, many generous people have contributed time, talents, money, and artifacts to the museum. Johns Hopkins University Applied Physics Laboratory provided on loan invaluable artifacts from Operation Bumblebee that gave the museum its initial focus. In 2005, the museum undertook a gigantic expansion project, maintaining the integrity of the building's original function while doubling in size. (Courtesy of Missiles and More Museum.)

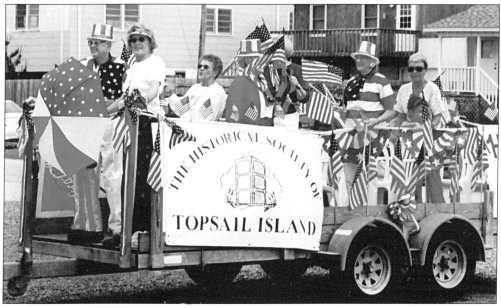
Even though the Assembly Building has been named a lot of things in over five decades, the Arsenal Centre seems to be the one that stuck the most with many residents. Collecting items from the post–Operation Bumblebee years is a part of preserving island history. Shown here is a matchbook from the arsenal days when food was the main fare, not rocket fuel. (Courtesy of Missiles and More Museum.)

When the town of Topsail Beach celebrated its 40th birthday, it sponsored a parade to commemorate the occasion. With strong community ties, the historical society put together a red, white, and blue float, shown here, to help celebrate the event. The parade began in front of the Assembly Building and continued through town with plenty of onlookers cheering from the sidelines. (Courtesy of Missiles and More Museum.)

After a storm, structural remains of a shipwreck were found on the beach about 80 yards north of the old Barnacle Bill's Pier. Massive iron pins were used to fasten the 10-inch wide timbers, with a visible curvature that indicated it was part of a ship's hull. Linda Holcomb, pictured here, and her mother discovered the wreck and took photographs that were donated to the museum. (Courtesy of Linda Holcomb.)

According to the Underwater Archaeology Unit's shipwreck files, the wreck is probably the *William H. Sumner*, a 572-ton, three-masted schooner built in 1891 in Maine. In 1919, she went aground off Topsail Inlet, and her captain allegedly committed suicide the next day. Two years and two trials later, the first mate was acquitted of murder. The U.S. Coast Guard destroyed the vessel's remains with explosives. (Courtesy of Linda Holcomb.)

From humble beginnings, the museum has grown into something the community can be proud of. Shown here, from left to right, are former historical society president Sue Newsome, Rose Bunch, and former Missiles and More Museum director Evelyn Bradshaw. Thanks to the generosity of members like Rose Bunch, the museum has fabulous displays, including her world-class collection of shells from around the globe. (Courtesy of Missiles and More Museum.)

This model of the *San Felipe* was built by Joseph Walter Best Sr. of Clinton, North Carolina. His wife, Betsy Caison Best, is the daughter of Cicero Hillary Caison and Annie Ruth Caison, who owned Caison Brothers Building Supply Company, located in the Assembly Building from 1949 to 1956. The Bests donated the display case and the Dutch merchant ship's model, typical of those used by pirates. (Courtesy of Missiles and More Museum.)

If rockets are fired out over the ocean, it stands to reason that eventually some of the debris will wash ashore. A spent solid-fuel rocket used to boost the ram-jet up to speed was uncovered on Topsail Beach in front of the Norman Chambliss Jr. property pictured on page 105. Word spread quickly of the find, and the rocket was "stored" under the crossover. (Courtesy of Julia Barnes Sherron.)

Haynes (left) and Neill Sherron found the rocket sticking out of the sand near their home. The discovery caused quite a stir. Norman Chambliss Jr. left home for an engagement and came back to find an explosives team and various law enforcement vehicles in his yard. It was determined that the rocket was safe, and today it is showcased in an aquarium in the museum. (Courtesy of Julia Barnes Sherron.)

Camp Davis and the Women's Air Service Pilots (WASPs) who flew targets over Topsail during World War II hold a prominent place in the museum. Many men and women who served in the military, particularly in this area, have donated photographs and memorabilia. Shown here is a good example of capturing a memory—a photograph taken in 1947 of Stacy Herring Britt, father of Jo Anne Paulin. (Courtesy of Jo Anne Britt Paulin.)

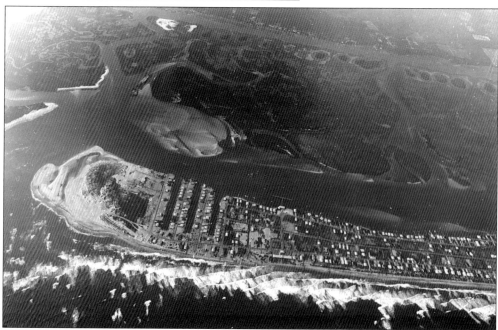

Aerial photography has been extremely popular throughout the years on the island. Many locals have photographs of their homes and of the island that date back to Operation Bumblebee days. This shot from the 1970s is of what is arguably the most popular spot on the island, the southern tip. (Courtesy of Phil Stevens and the Wayne Reynolds family.)

Five

THE GOLD HOLE

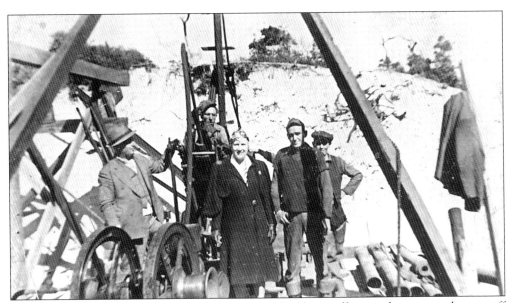

In 1750, a Spanish flota of five vessels was reportedly blown off-course by a tropical storm off the Carolina coast. A typical Spanish galleon's journey could be traced from Spain to South America, where they loaded up with gold to take back to their homeland. One of the ships, the *El Salvadore*, was the first to be lost, reportedly breaking up in New Topsail Inlet. All but four crew members drowned, and with them sank a fortune in pieces of eight regular—pieces of eight with no pieces broken off—and all personal cargo. Nearly 200 years later, treasure hunters set up shop on what was still a remote island. After four years and thousands of man hours removing sand, the project was mysteriously abandoned in the middle of the night. No one really knows if gold was ever found or why the operation was abandoned so abruptly. Shown after the A-frame was constructed are, from left to right, Harry Gunning, Richard Sidbury, Mildred Stone, Roger Moore, and Walter Moore. (Courtesy of David Stallman and *Echoes of Topsail*.)

47

Situated near today's Topsail Beach town line is what remains of the "Gold Hole." The Bland property, now owned by the Mayrands, was leased to Bill Walker, relative of the legendary mayor of New York James J. Walker. Bill Walker headed up the Carolina Exploration Company's search for gold from 1937 to 1941. All supplies were brought over by boat to this landing. (Courtesy of David Stallman and *Echoes of Topsail*.)

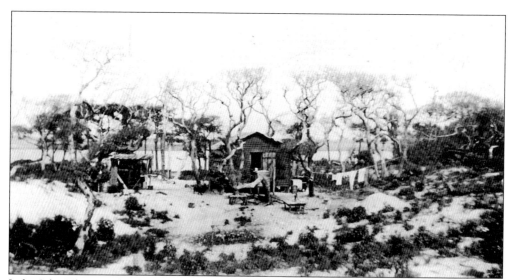

Judge John Thomas Bland from Burgaw originally bought the "Gold Hole" property in the 1920s, long before speculation of lost gold. A rustic one-room fishing shack was built in the 1930s, which later served as the headquarters for the excavation. Heirs of Judge Bland used the fishing shack until it burned in the 1960s. (Courtesy of David Stallman and *Echoes of Topsail*.)

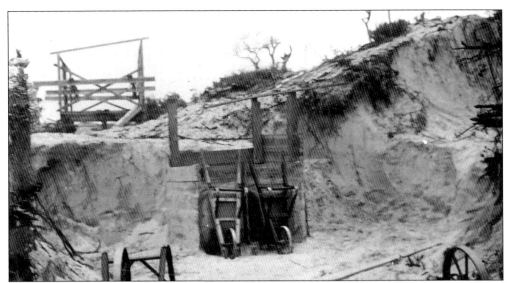

Bill Walker hired local workers to set up and conduct the excavation, including Kenneth Andrews, Ivy Lewis, Abraham Spicer, and Richard Sidbury. Rudimentary efforts began with shovels, wheelbarrows, and hand-built wood frames. Newspaper reports from the *Wilmington Star* in 1938 talked of "rotten wood" that was brought up which had been "hand-tooled," giving encouragement to the gold-seekers. (Courtesy of David Stallman and *Echoes of Topsail*.)

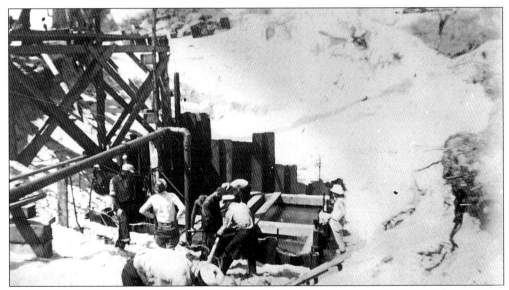

Simon Lake, involved in the history of submarine development, served as some type of consultant, while key player Julian S. Jacobs often visited with Bill Walker to check on the progress and supervise. When enough sand had been dug out by hand, well-drilling equipment was used. After a time, the walls had to be shored up to keep the sand from caving back in. (Courtesy of David Stallman and *Echoes of Topsail*.)

The project began when Julian S. Jacobs, a mining engineer from New York and president of the Carolina Exploration Company, became interested in a scientific metal locator. He tested the invention, first prospecting in several mines in North Carolina then along the coast for treasure. His "diviner" operated on some "unrevealed principle of radioactivity of elements," according to newspaper accounts from 1939. (Courtesy of David Stallman and *Echoes of Topsail*.)

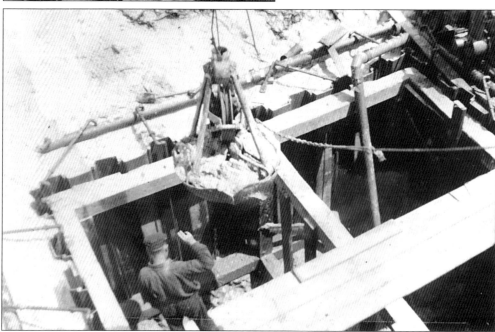

The shaft was dug to a depth of approximately 40 feet, with the width varying between 20 feet and only 4 feet square by the end of the project. Once the hole deepened, especially after it reached below the water line, a drive bucket was used to take out the sand, and pumps were used in the struggle to keep out the water. (Courtesy of David Stallman and *Echoes of Topsail*.)

Six

THE WEATHER

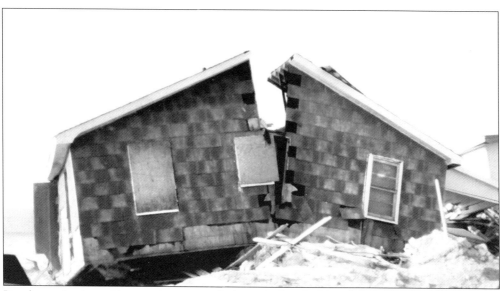

People are fascinated by weather, particularly at the beach. Very few gatherings occur without talk of how beautiful the day is, how strong the winds are, or what the weather will be like in the morning. And almost every islander has a weather-related story to tell, whether about a hurricane, a tornado, a northeaster, or even the rare but occasional snowstorm. The encouraging thing is that people have lived to tell about these bouts of nasty weather and, even more importantly, a hefty number stayed, not to be scared away. And with few exceptions, long-timers have a healthy respect for weather, taking warnings and watches from the National Weather Service seriously. Ask a dozen people what they do to prepare for hurricanes and you'll get a dozen different answers, but anyone who has been here for long will definitely have an answer. This broken house was damaged in one of the devastating hurricanes to hit on or near Topsail in the 1990s. (Courtesy of Dr. and Mrs. Howard Braxton.)

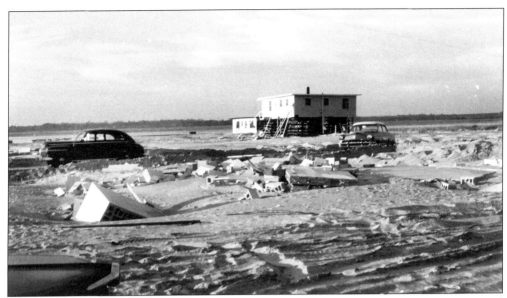

Hurricane Hazel was the "big one" that hit on October 15, 1954, bringing with it sustained winds of 125 miles per hour. Most island structures were leveled. Traveling at speeds often over 30 miles per hour, this fast-moving storm left a death toll estimated at over 100 in the United States, although none on Topsail, and as high as 1,000 in Haiti. (Courtesy of Phil Stevens and the Wayne Reynolds family.)

What wasn't totally destroyed, Hazel buried in the sand or tossed miles away. Stories of people finding possessions months and years later aren't uncommon. Hazel hit on the worst day possible, when the moon was full and the tide was the highest of the year. Tides 9.6 feet above mean sea level were reported, which washed over the entire island. (Courtesy of Phil Stevens and the Wayne Reynolds family.)

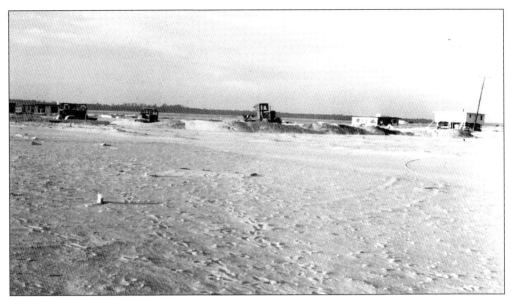

Equipment was out in force after Hazel, attempting to clear the devastation and debris. Many homes were built on concrete slabs, which did not hold up well to the storm surge and flooding. After Hazel, more houses were built on pilings to allow water to pass underneath without such catastrophic damage, and building codes were revised to handle higher winds. (Courtesy of Phil Stevens and the Wayne Reynolds family.)

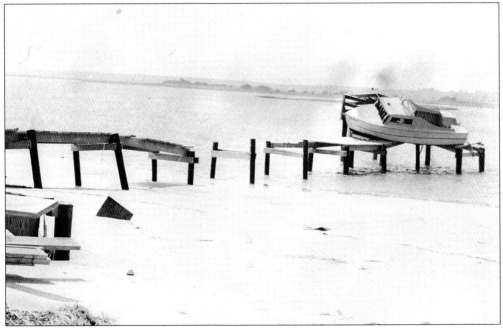

This boat and dock belonged to Dr. and Mrs. Donnie H. Jones Jr. of Topsail Beach. Hazel's 125-mile-per-hour winds threw this boat into their sound-side dock. After the hurricane, both were repaired and used again. Hurricanes are classified by the Saffir-Simpson hurricane intensity scale. Hazel was a category four, with maximum sustained wind speeds between 131 and 155 miles per hour. (Courtesy of Marianne Jones Orr and family.)

The Edmondson family started building their summer home in November 1950, completing construction in April 1951. This was one of the first houses in Topsail Beach and the only home on the sound between the Breez-Way and Surf City. An interesting note is that they probably had the island's first sunken bathtub, a claw-foot tub placed in a hole surrounded by cement. (Courtesy of Mr. and Mrs. Spenser Edmondson.)

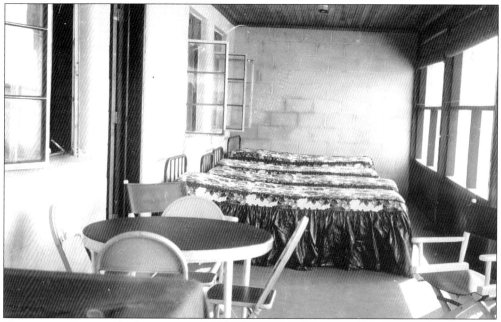

Sleeping porches were built ocean- or sound-side to take advantage of being on the water. These porches offered pleasant places for children of all ages to rest and relax and enjoy being together at the beach. Ventilation from the screened porches also helped cool the homes, since ocean breezes were the only air conditioning for summer cottages during the 1950s. (Courtesy of Mr. and Mrs. Spenser Edmondson.)

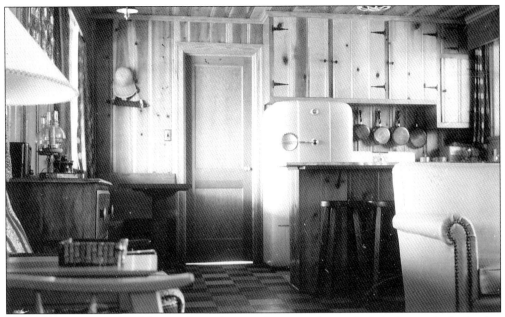

This is a great example of the wood paneling used in many homes built before and rebuilt after Hazel. Walls, floors, and often ceilings were of tongue-and-groove knotty pine, with some homes having cypress, juniper, or cedar. When the wood was new, most homeowners stained or shellacked the paneling, which held up well to the elements. In recent years, a lot of this paneling has been replaced or painted. (Courtesy of Mr. and Mrs. Spenser Edmondson.)

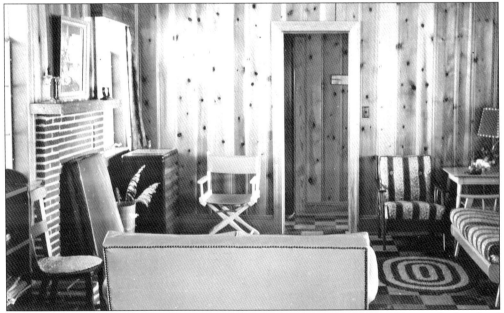

Summer homes were usually built for ease of care and convenience. By 1950s standards, island homes were comfortable and spacious, and many of the owners only came for weekends or vacations. As the population of Topsail Island has grown, so have the size of the rooms and houses. This den was typical, giving the Edmondson family plenty of room for family gatherings and company. (Courtesy of Mr. and Mrs. Spenser Edmondson.)

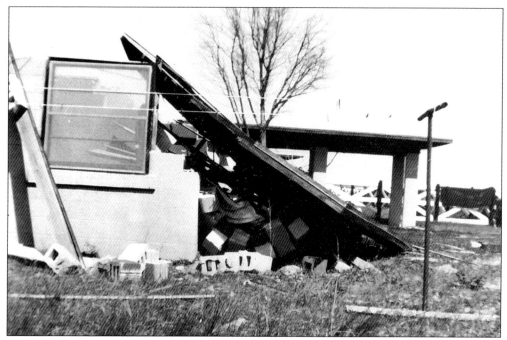

Anyone who has survived a few hurricanes knows that some of the worst damage on Topsail Island has occurred by tornados spawned during these storms. At landfall, conditions are favorable in hurricanes for tornado formation. The tornado that struck the Edmondson house was not, however, related to a hurricane. (Courtesy of Mr. and Mrs. Spenser Edmondson.)

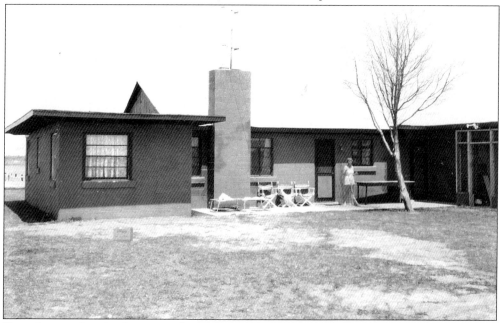

If you live on the island or own a house here, your chances of having damage from a weather-related event are pretty good. In the case of the Edmondsons, they rebuilt their home after the tornado in 1958 and enjoyed it for many years, coming to the island often. Shown here is Estelle Bowden Edmondson. (Courtesy of Mr. and Mrs. Spenser Edmondson.)

Look closely past the pilings to the house in this photograph. It was lifted up during Hurricane Fran in 1996 and deposited in the sound, where it floated or was washed aground to where it is shown here. Some of the houses that ended up in the sound were brought back ashore, while others were scavenged for parts and taken apart piece by piece. (Courtesy of Julia Barnes Sherron.)

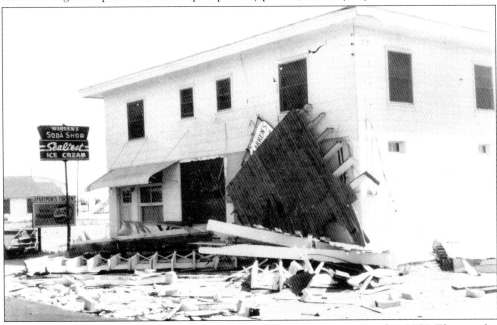

The original Warren's Soda Shop was heavily damaged in Hurricane Hazel in 1954. The popular hangout opened back up after the storm but eventually moved a few blocks north in 1959. The sign shown here was moved with the shop, as evidenced in the photograph of the new location on page 102. (Courtesy of Paul and Susan Magnabosco.)

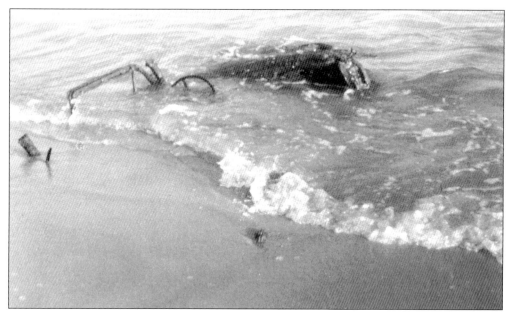

As was sometimes the case, fishermen would drive their vehicles onto the beach, the tide would come in, and they would be stuck. It is suspected this is what happened in the 1950s to the jeep in the photograph, except this time the owners left it there for good. A combination of time and tides eventually covered it up in sand, as evidenced in this 1978 photograph, although it purportedly was in full view in 1977. (Courtesy of Dr. and Mrs. Howard Braxton.)

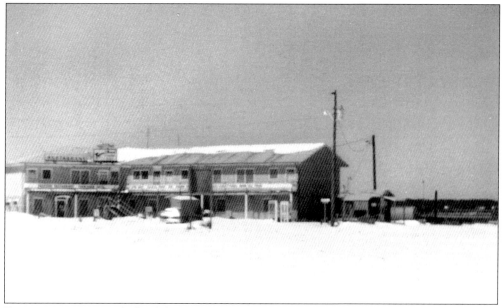

Snow is rare on Topsail Island, but it has occurred several times in the past 30 years. Here is an example of good accumulation of snow at the Topsail Sound Pier on the south end of the island. Seeing snow on the beach and dunes and snowflakes fluttering over the water is something many islanders remember fondly, but good photographs of the actual event are hard to capture. (Courtesy of the Oppegaard family.)

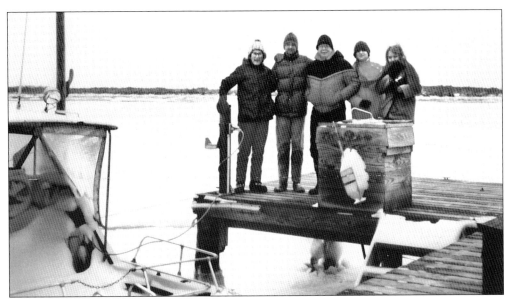

In December 1989, Topsail experienced a lot more than snow. The sound looked like a large pond of ice, frozen from the cold. Taken sound-side on a dock in Topsail Beach are, from left to right, Evelyn Bradshaw, her son Brad, Hardy Wessell, his granddaughter Amanda Hutton, and his daughter Nancy Wessell Hutton. (Courtesy of the Bradshaw family.)

This photograph appears to be taken at night because the sky is so dark, but it is actually a daylight shot of a storm brewing out over the sound. The view shows Godwin's Market and a former restaurant, both a block from the beach, on Anderson Boulevard to the front and Ocean Boulevard to the back. (Courtesy of Charles Hux.)

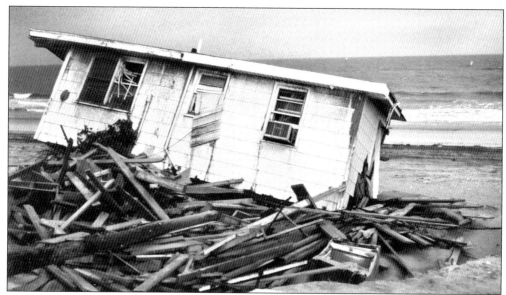

This is typical of the horrific damage on Topsail during the string of hurricanes that hit in the late 1990s. Hurricane Floyd was a strong category three, with sustained winds of 130 miles per hour. Nearly twice the size of typical Atlantic hurricanes, Floyd measured 580 miles across and made landfall on September 16, 1999, near Cape Fear, less than an hour from Topsail. (Courtesy of Dr. and Mrs. Howard Braxton.)

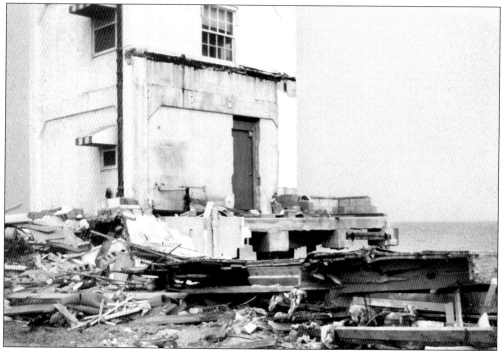

Tower Number Three of the eight photographic towers from Operation Bumblebee stands tall after Hurricane Fran hit the Bland (then Ottoway) tower home on September 5, 1996. The strength of the construction of the concrete towers is evident, since only the tower remained and the adjoining house was demolished. (Courtesy of Dr. and Mrs. Howard Braxton.)

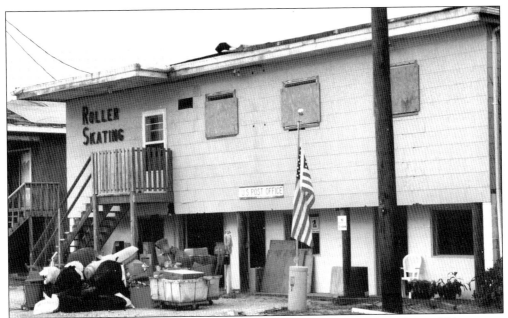

Fran made landfall near Cape Fear, North Carolina, and the eye moved directly over Wilmington, a mere 40 miles south of Topsail. A category three on the Saffir-Simpson scale, Fran had sustained winds of 115 miles per hour on the coast. The Skating Rink and Topsail Beach Post Office, both owned by Doris and Sonny Jenkins, stood up to Fran and are shown here in the cleanup stage. (Courtesy of Julia Barnes Sherron.)

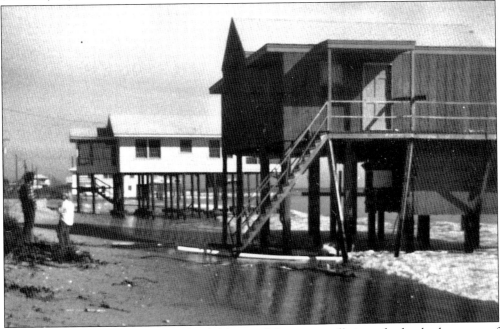

Sometimes Mother Nature deals a harsh blow, and the ocean rolls in and takes back an area of the beach. Over the past three decades, a few houses, like this one, have been moved to other locations off of the beach for safety. In recent years, more and more houses are being moved to make room for larger, more expensive homes. (Courtesy of Dr. and Mrs. Howard Braxton.)

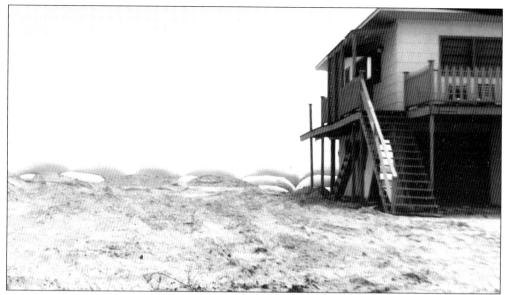

Sometimes dunes are breached by storm surges or high tides, and sandbags are used to provide temporary protection to imminently threatened structures. They also control the flow of debris in the event of flooding. Sandbags, like those shown here, were probably used after a northeaster (nor'easter), which usually brings gale-force winds from the northeast, coastal flooding from abnormally high tides, and heavy precipitation. (Courtesy of Dr. and Mrs. Howard Braxton.)

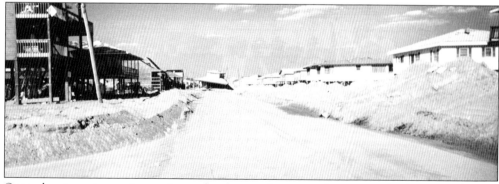

Once a hurricane is over, it sometimes takes days, weeks, or months to assess the damage and secure the island before residents can return to what is left of their homes. The stronger the hurricane and the more extensive the damage, the longer it may take before residents are allowed back. As evidenced in this photograph, roads are often blocked with houses and large debris that cannot easily be moved. (Courtesy of Dr. and Mrs. Howard Braxton.)

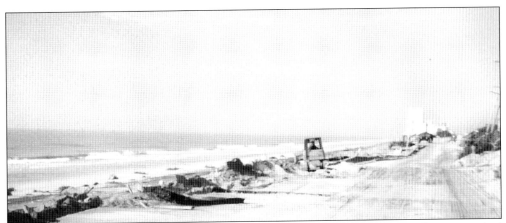

Hurricane Fran slammed into Topsail with gusts as high as 125 miles per hour. Residents were asked to use four-wheel-drive vehicles and to enter at low tide so they could drive on the beach, because the only road connecting Surf City and Topsail Beach was washed out in areas. Heavy equipment was brought in to temporarily repair the roads. (Courtesy of Dr. and Mrs. Howard Braxton.)

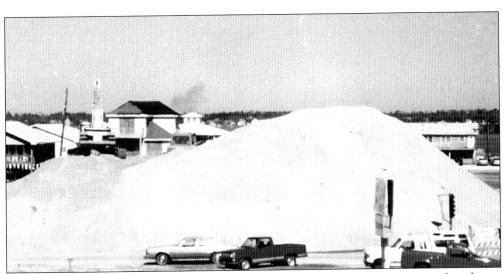

Blowing winds, storm surge, and coastal flooding combine to bring vast amounts of sand onto the island's interior, covering yards and roads and most everything else. During more recent hurricanes, the collected sand was piled into a huge mountain in front of the Sea Vista Motel and later placed back on the beach to rebuild the dunes. (Courtesy of Martha Alexander.)

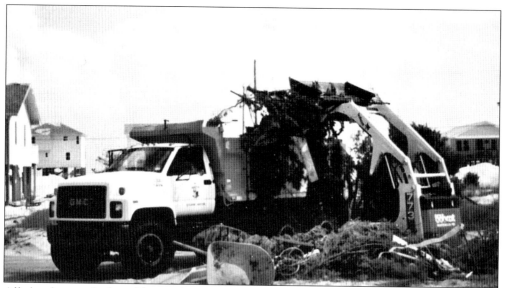

All that has washed up, blown off, or was destroyed has to be used or removed. The task is gigantic, requiring massive amounts of community cooperation. Hundreds of loads of debris are trucked away. One piece of advice old-timers give is to label exterior steps and decks so that they can be identified in case they are washed ashore somewhere down the beach. (Courtesy of Dr. and Mrs. Howard Braxton.)

This photograph shows the magnitude of the cleanup after a major hurricane, which means a category three or above on the Saffir-Simpson Scale. The names of particularly devastating hurricanes are retired, not to be used again. Hazel (1954), Fran (1996), and Floyd (1999) are among those to hit Topsail that are retired but, among islanders, never forgotten. (Courtesy of Missiles and More Museum.)

Seven

SURF CITY

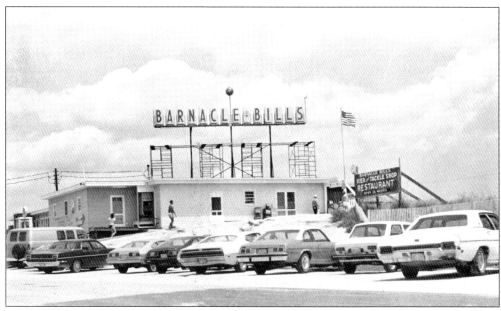

In the early days of Topsail Island after Operation Bumblebee, incredible fishing was the main draw that brought people to the island. Fishing businesses of all types started popping up along the coast. Fishing piers were being built here in record numbers. Charles ("Charlie") Venson Medlin of Bailey and his wife, Bettie Gray Morgan of Samaria, came to Topsail to make a home for their family and a living from the sea. After founding Coastal Ice and Seafood, working a large fish and seafood route inland, and managing another fishing pier in the area, the Medlins bought the Barnacle Bill's Pier in 1966. The pier's attractions grew to include an attractive retail and entertainment complex complete with two restaurants, a campground, a motel, the Ship "Wreck" Room Oceanside Arcade, and the Island Hideaway Gift Shop, as well as the pier. (Courtesy of the Medlin family.)

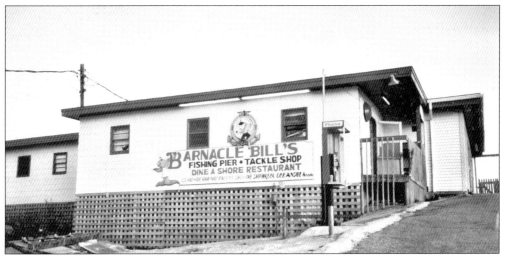

Recycling buildings was commonplace. In Surf City, the former Officers' Club was integrated into the Barnacle Bill's complex. The military returned the property, including the club, to the Yow family in the late 1940s. Over the years, the fine-dining oceanfront restaurant, Dine Ashore, was hugely popular. First managed by Bettie Medlin, then later by her daughter, Sue Smith, the upscale cuisine was an island favorite. (Courtesy of Missiles and More Museum.)

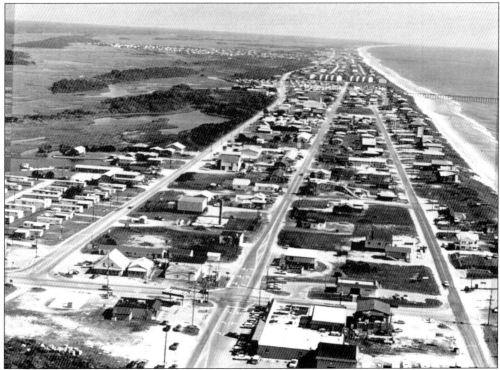

Incorporated in 1949, Surf City was the first official town on Topsail. What started as a few abandoned military buildings has grown beyond this 1980s view. The first board of commissioners included Mayor David Lucas, who was also commissioner of public safety; Gerald Mercer, commissioner of finance; and A. H. Ward, commissioner of public works. Each received $25 per year for their services. (Courtesy of Christopher Rackley of Lewis Realty.)

On an island, fire services are often difficult to fund and sufficiently man. Topsail Islanders have a long history of dedicated volunteerism for fire protection. Shown here is one of the many fire trucks used over the years in Surf City. Today's equipment includes platform, tanker, and utility trucks, as well as "first-out" and material aid engines. (Courtesy of the Medlin family.)

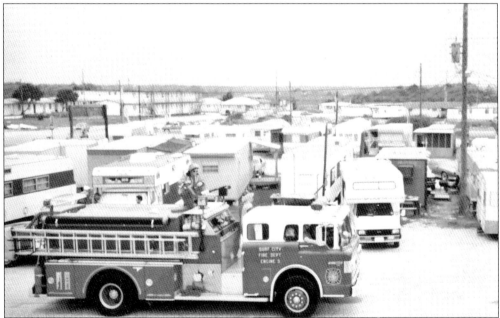

Volunteer firefighters do more than respond to fires, as shown here in a demonstration during a parade in the Surf City campground located near the former Barnacle Bill's Pier. Today the town's fire department has grown to include 5 full-time paid firefighters, who also serve as fire inspectors, and 20 volunteer firefighters. (Courtesy of the Medlin family.)

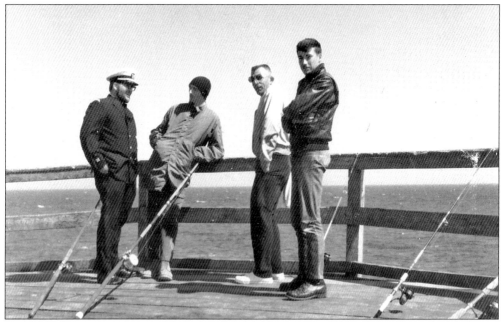

Even though piers have come and gone in the past 50 years, they are still popular gathering places for spectators, fishermen, and the occasional couple who wants to wed. In addition to those shown in this book, some of the piers remembered fondly include the Scotch Bonnet and Salty's Piers in North Topsail Beach and the Dolphin Pier, whose jagged pilings still remain near Queen's Grant. (Courtesy of the Medlin family.)

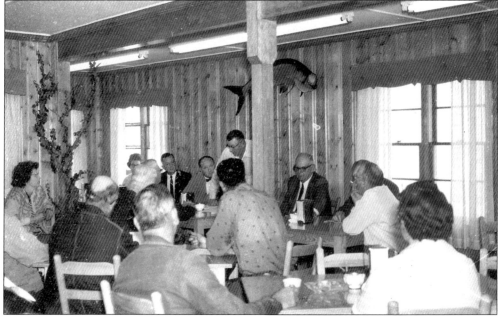

Paradise Pier was located across from Rogers Bay Campgrounds, near St. Moritz condominiums in West Onslow Beach, now North Topsail Beach, but it was included here because it was managed for a time by the Medlin family of Surf City. The photograph shows what was probably a fishing club meeting in the pier's restaurant. (Courtesy of the Medlin family.)

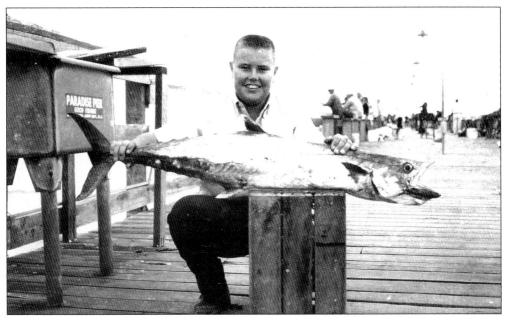

The possibility of catching something interesting on area piers is pretty good. Favorite catches include amberjack, tarpon, Spanish and king mackerel, and blues. This fisherman had good luck on Paradise Pier, but the pier's luck did not hold out. It met a fiery end in the late 1980s, going up in a blaze so quickly that people jumped into the ocean and swam ashore. (Courtesy of the Medlin family.)

In addition to the Dine Ashore restaurant, there was a casual grill at Barnacle Bill's Pier. Owner Charlie Medlin (right) is shown at the grill talking to the "juke box man" who serviced the arcade. The family-owned and -operated business included the Medlin children—Doug, Dan, and Sue Medlin Smith—with their spouses and children also pitching in to help. (Courtesy of the Medlin family.)

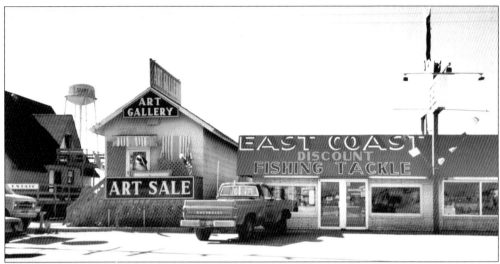

Charles and Bettie Medlin founded Coastal Ice and Seafood where the Fishing Village is located today, just over the causeway on the right. In this photograph is East Coast Discount, housed in the remodeled Coastal Ice building. East Coast Discount later became East Coast Sports. Read below for more on the building to the far left next to the art gallery. (Courtesy of the Medlin family.)

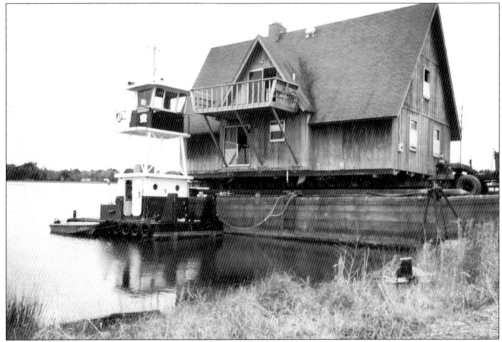

After the storms of the 1980s, several oceanfront homes were moved to interior lots or the mainland. This house did just the opposite. In 1987, it was floated by barge from the mainland and placed on the island next to the East Coast Discount complex and used as a real estate office for Cathy Gandy Medlin. Most recently, this area is now the Fishing Village. (Courtesy of the Medlin family.)

Tourism has become big business, with the island's population multiplying many times over during high season, which once was June, July, and August but now has stretched from March to November. For non-fishermen, fresh seafood can be bought straight from the boats or at local seafood markets like the one shown above. (Courtesy of Missiles and More Museum.)

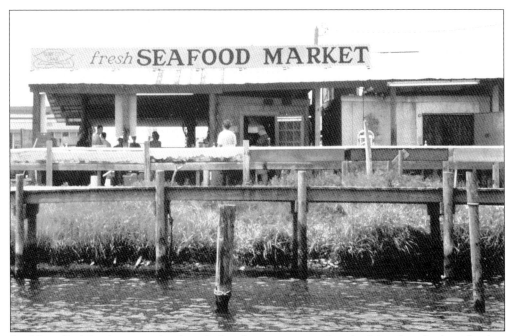

Surf City Crab has been an island staple for a long time, providing fresh local seafood to islanders and visitors alike. Located a short distance from the swing bridge at the entrance to the island, the seafood market sits sound-side right behind the Crab Pot, a local eatery and night spot. (Courtesy of Julia Barnes Sherron.)

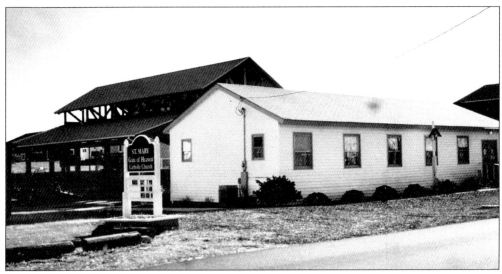

On the corner of Wilmington Avenue, stretching from North Shore Drive to North Topsail Drive, is the lovely second-row home of St. Mary Gate of Heaven Catholic Church in Surf City. In addition to the regular sanctuary, a covered open-air structure is used for mass and other services. (Courtesy of Missiles and More Museum.)

Longtime residents and visitors have filled the Surf City Baptist Church for decades. Even though in recent years additional churches have been added on and near the island, this Surf City church has stood the test of time. Located on the corner of Wilmington Avenue, the church grounds go from North Topsail Drive to North New River Drive. (Courtesy of Missiles and More Museum.)

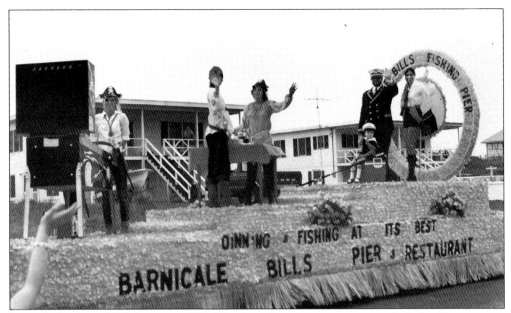

Topsail's first Pirate's Jubilee was in 1979. The three-day community event included surfing contests, Calico Jack's treasure hunt, fish dinners, pancake breakfasts, military displays, powerboat races, and a parade. Pictured here is a Barnacle Bill's float from an early jubilee. The first chairman was Cookie Tilghman of Tilghman Square, one of the island's earliest shopping centers, featuring Shenanigans Beach Club and Cookie's Treasure Chest. (Courtesy of the Medlin family.)

Edgar Herring came to Topsail after Hurricane Hazel, working in construction before starting Herring's Bait and Tackle Shop in a local marina. His skills at reel repair helped him build up a good business. In 1968, Herring's Outdoor Sports was built. Edgar's daughter, Peggy Bailey, and Jessie and Steve Bailey continue to run the popular business in the same location where they have been for over 35 years. (Courtesy of Bev Green.)

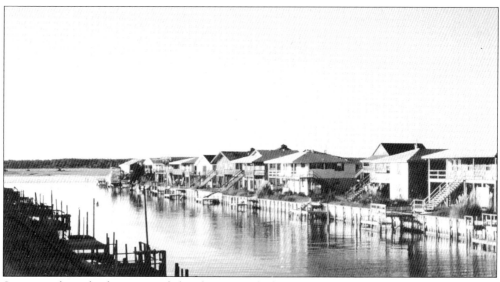

Some people prefer the ocean, while others swear by life on the sound, but a third choice became popular several decades ago when channels or fingers were cut inland in the northern section of Surf City. The lots bordering the channels were populated over the years, with most streets offering a mix of housing from mobile homes to multi-level housing in all sizes and price ranges. (Courtesy of Martha Alexander.)

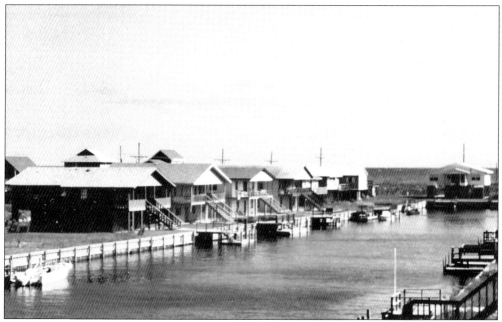

Living on "the canals," as islanders refer to the property next to the fingers of water in Surf City, became desirable for their easy access by boat to the waterway. "Front yards" filled with private docks and pleasure craft, and fishing off the docks became an everyday pastime. Close-knit neighborhoods have developed on various streets, with block parties common and families returning for generations. (Courtesy of Martha Alexander.)

For years, campgrounds filled both parcels next to the swing bridge. Surf City purchased the property to the right upon entering the island and turned it into the spectacular Soundside Park complete with a boardwalk, fishing pier, playground, and bandstand, all overlooking the waterway. Blackbeard's Treasure Family Campground is still on the left, offering gorgeous views of boaters waiting for the bridge. (Courtesy of Missiles and More Museum.)

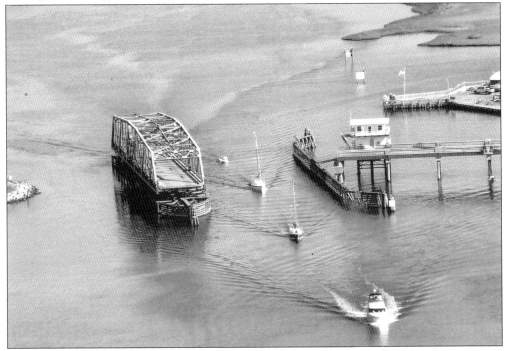

This is a view of the swing bridge completely open allowing pleasure craft (shown here), as well as commercial fishing vessels and barges, to travel the Intracoastal Waterway. During World War II, the waterway was used as a means of avoiding the potential risk of American ships being attacked by submarines that frequented the shores off North Carolina. (Courtesy of Traci and Dan Hackman.)

Rescue squads have a long history of providing emergency services to rural areas and small towns like Surf City, North Topsail Beach, and Topsail Beach. Volunteers organize, prepare, and train to be ready to provide care and transport to residents and visitors. Early Surf City Rescue Squad members are, from left to right, Estelle Sherwood, Hiram Williams, and Bettie Medlin. (Courtesy of the Medlin family.)

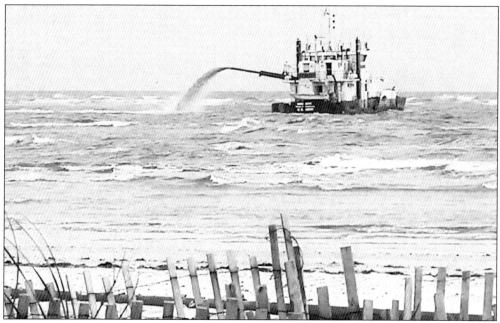

Dredging vessels are usually equipped with 40- to 50-foot pipes that navigate the inlets and waterways, throwing the sand to the banks to keep channels open for commercial and recreational boating. Over time, natural erosion, currents, and storms cause sand to move into inlets, making them impassable if not removed. (Courtesy of Bev Green.)

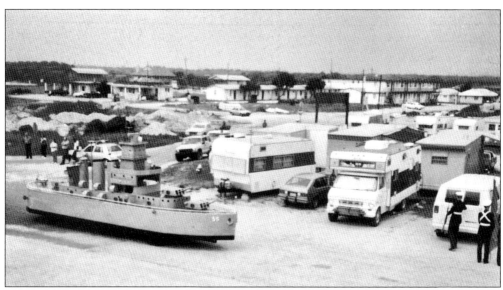

Parades were popular on Topsail. This photograph, taken in the 1980s, is a good example of the strong military presence in the area. It is no surprise that a "battleship" float was in the parade, since the battleship North Carolina is docked in nearby Wilmington and Marine Corps base Camp Lejeune is located on the mainland north of the island. (Courtesy of the Medlin family.)

Growing up on the island was an adventure. There was very little here in the 1940s and 1950s, so families dreamed up their own forms of entertainment. Even in the off-season, the beach was always a good source for things to do. Shown here in February 1956, Sue and Doug Medlin are dressed in their winter clothes. (Courtesy of the Medlin family.)

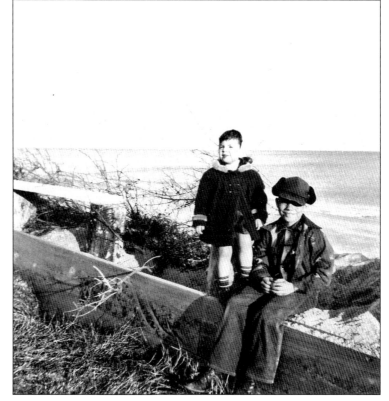

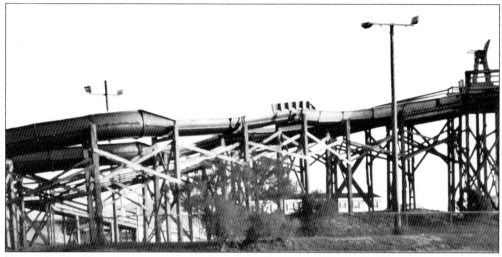

Many islanders have happy memories of going to the waterslide in Surf City, a huge monolith near the ocean. Close to the same location, there was once a carnival with a Ferris wheel, and another time there was also an amusement park with a go-cart track. None of the above enterprises lasted for long periods, but while they were here, people loved them. (Courtesy of Missiles and More Museum.)

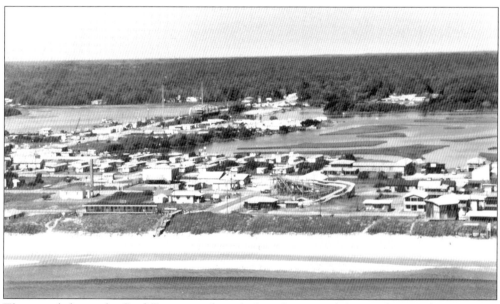

This aerial shows the Surf City oceanfront before the waterslide was destroyed in a storm. Photographer Bev Green took this and other aerial shots while helping with turtle research. Generous with her talents and time, she has worked extensively with the turtle hospital, and her photographs can be seen in exhibits at the Missiles and More Museum and at the North Topsail Beach Town Hall. (Courtesy of Bev Green.)

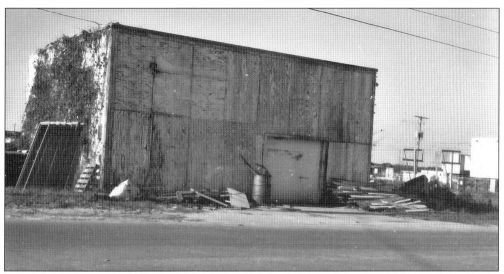

Roland and Sally Batts lived in and ran a grocery store and post office out of this old military firehouse. Roland was mayor of Surf City from 1957 to 1964, and when he died, his wife finished out his term. Their daughter Diane Geary and her husband owned a souvenir and clothing store in Surf City called the Ship's Wheel. (Courtesy of Missiles and More Museum.)

The military built this house during the Operation Bumblebee era in the 1940s and used it as a checkpoint for people coming onto the island. Later it was transformed into a home and used for many years by the Medlin family. Today Treasure Coast Square sits on the former site, both owned by Dan Medlin and Sue Medlin Smith. (Courtesy of the Medlin family.)

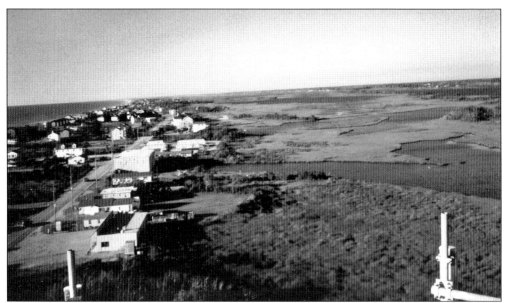

This shot was taken by Howard Comer on top of the Surf City water tower while he was up there changing the lightbulb. To the right is the Intracoastal Waterway and to the far left, the Atlantic Ocean. Rivers, estuaries, and sounds are connected by man-made cuts to form the federally maintained, toll-free waterway that provides protected passage for commercial and pleasure craft. (Courtesy of Howard and Melissa Comer.)

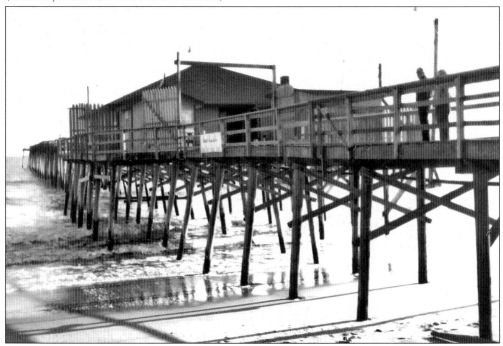

Built in 1948, the Surf City Pier was Topsail's first ocean fishing pier. Still in its original location, the pier can be found on South Shore Drive between Kinston and Roland Avenues. In 1954, a storm took it out, and the pier was replaced by a steel one. Unfortunately the steel rusted over time and has been replaced with wood. (Courtesy of Missiles and More Museum.)

Topsail has been a fisherman's paradise for everyone from novices to serious anglers. Some fishermen, like the one shown here, came prepared, complete with waders. Most piers and tackle shops offered rental equipment and sold bait. A snapshot of the day's catch was often taken and given to the fishermen as proof-positive the fish were running. (Courtesy of the Medlin family.)

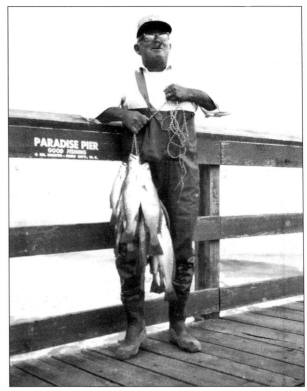

An old postcard caption reads, "Miles of uninhabited beach extends to the north and south of the pier giving the surf fishermen equal chance for fine catches." This fisherman was a happy camper with his catch of the day. Daily tides and rod and gun club announcements can be read on the board. (Courtesy of the Medlin family.)

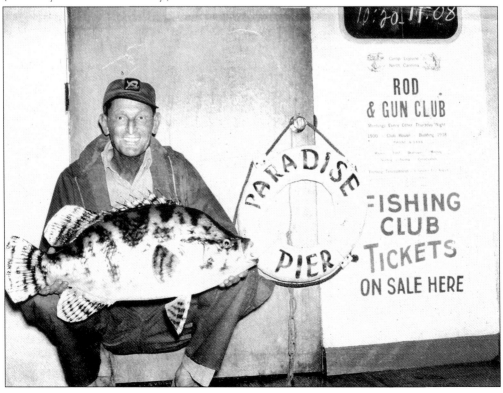

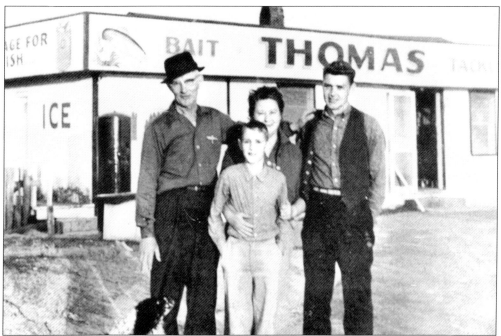

Owner and operator George R. Thomas Sr. ran Thomas Seafood and Tackle for over 30 years in its location shown here at Sears Landing. In the late 1950s, a trailer park and restaurant were added, as was the new sign. The family-owned business included, from left to right, their dog Tubby, George R. Thomas Sr., Elvie Thomas, George L. Thomas, and Doug Thomas (front), who still runs the business today. (Courtesy of Doug Thomas.)

Thomas Seafood and Tackle began in this building owned and constructed by Leroy Batts from Kinston. George R. Thomas Sr. leased the building in the mid-1950s and ran his popular seafood and tackle shop there until the property was sold. The Sears Landing restaurant is now on the former site, and Thomas Seafood has opened a new store right down the road on Highway 50/210. (Courtesy of Doug Thomas.)

Eight

TOPSAIL BEACH

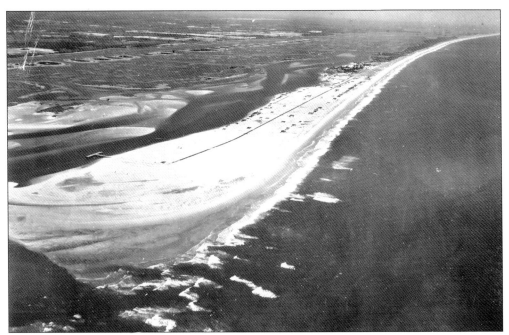

"One of the nicest places to live this side of heaven" is how developer J. G. Anderson Jr. advertised New Topsail Beach in the late 1940s. Topsail Beach got its illustrious beginnings, in part, due to the dreams of Anderson and other like-minded entrepreneurs. According to the brochure, "The first lot on New Topsail Beach was sold June 16, 1949. There are now more than six miles of improved roads, almost two miles of seawall completed on the Channel side, nearly 350 buildings, a nice non-denominational church, a building supply store, community stores, hotel, cafés, service station, electric lights, telephones, post office, school bus service, fishing piers and many other improvements. Additional construction starts almost daily." Although the Anderson and "downtown" areas developed, it would take a while before expansive construction of Topsail Beach extended to the southern part of the island, shown virtually empty in this 1950s-era aerial. (Courtesy of Phil Stevens and the Wayne Reynolds family.)

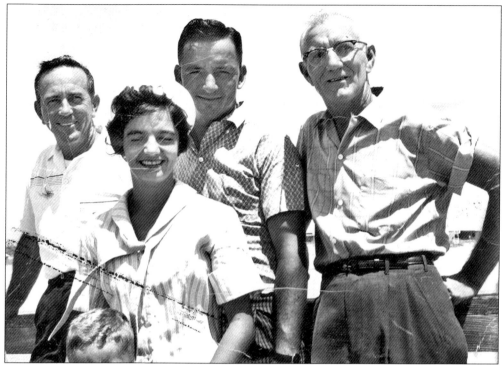

The Topsail Island Fishing Club has expanded over the years to become a strong organization with a growing membership who share an interest in sport fishing. Some of the people instrumental in starting the fishing club were Lewis Orr Sr., George R. Thomas Sr., R. L. Church, and Lewis Williamson. In this early 1960s photograph are, from left to right, Lewis Orr Sr., two unidentified people, and George R. Thomas Sr. (Courtesy of Doug Thomas.)

This is an early-1950s example of one of the numerous hunting blinds that were built in the sound-side marsh between Topsail Island and the mainland. Many of these small structures survived the ravages of hurricanes and storms for decades, with a rare few lasting into the 1980s. (Courtesy of Dr. and Mrs. Howard Braxton.)

In the late 19th and early 20th century, Topsail and surrounding areas were "discovered" by wealthy hunters and fishermen from surrounding states. Hunting and fishing lodges and camps were established all along the New River, on the island, and in both Pender and Onslow Counties. Some well-known ones were Onslow Hunt Club, Gulf Oil Lodge, and Weil Lodge on French's Creek. (Courtesy of Phil Stevens and the Wayne Reynolds family.)

Lib Keith Mallard loved the island and the chapel, holding the first Emma Anderson Chapel Sunday school class in August 1949 at her home in Topsail Beach. Today those first efforts with the youth have grown and expanded over the years to include a full-time summer youth program with a director. Shown with a great catch, Lib obviously also loved fishing. (Courtesy of Dr. and Mrs. Howard Braxton.)

J. G. Anderson Sr., shown here with Mrs. Walter Baker, was one of the original developers of Topsail Island. He purchased about one-and-a-half square miles of property at the southern end from Evelyn Empie and Helen Bridgers for the sum of $40,000. Empie, Bridgers, and Anderson grace the names of streets in Topsail Beach. (Courtesy of Phil Stevens and the Wayne Reynolds family.)

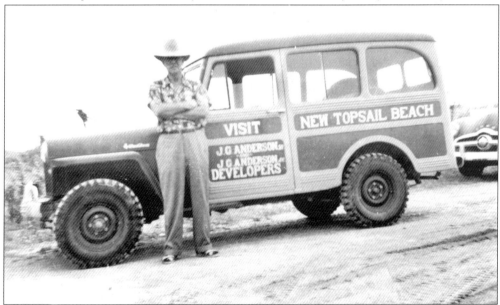

Anderson was known for a lot of quirky characteristics, not the least of which was his easily recognizable wagon, shown here. Another interesting fact was that he loved the color orange and used it everywhere: desk, furniture, files, even the walls in the office of his home. And it wasn't a subtle peachy color either; it was bright and bold, just like the man. (Courtesy of Phil Stevens and the Wayne Reynolds family.)

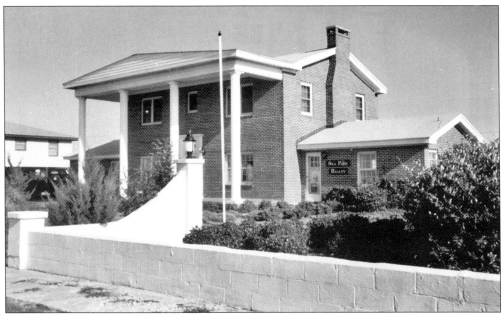

The Anderson house with its massive columns and brick construction was built in the early 1950s by J. G. Anderson Sr. for his wife, because she would not come until he built a house like her home in Wauchula, Florida. This was to have been a model home for Anderson's new community, but Hurricane Hazel stalled his progress in 1954. (Courtesy of Phil Stevens and the Wayne Reynolds family.)

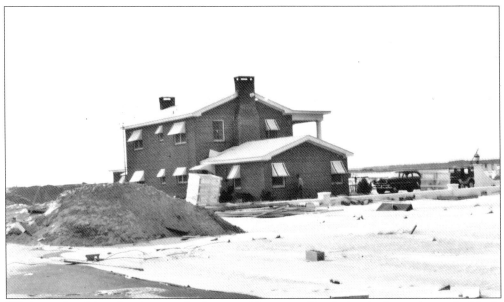

While much of the island was washed over in Hurricane Hazel, the Anderson house had little damage, as shown in this photograph taken right after the storm. At one point, Anderson operated his realty office in the house, complete with his signature orange on the walls. The present owners, Wayne and Michelle Reynolds and their family, once again use it as a private home. (Courtesy of Phil Stevens and the Wayne Reynolds family.)

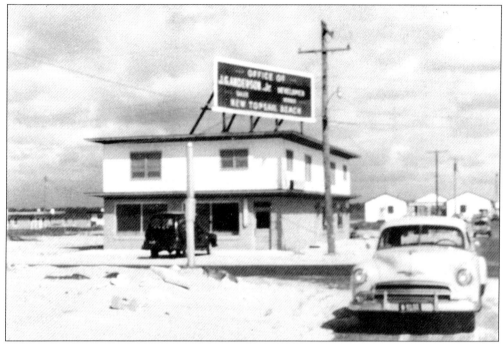

Anderson built his real estate office at the corner of Davis Avenue and South Anderson. A tremendous neon sign perched on top of what was originally a flat-top building. After the building housed various businesses, in 1979 Louis and Mary Lou Muery opened the Gift Basket, which is still a popular island shopping destination, now owned by Grier and Kristin Fleischauer. (Courtesy of Paul and Susan Magnabosco.)

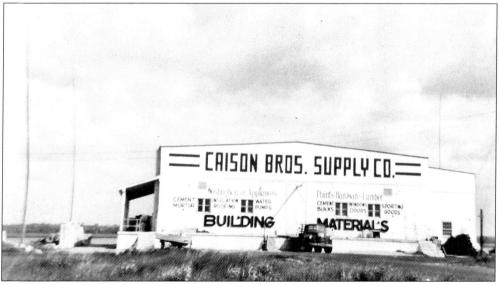

The Assembly Building began life in Operation Bumblebee, but during the past 50 years, it has been Caison's Brothers Supply Company (as shown here), the Red Barn Steakhouse, Roy Hill's Arsenal Centre, the Bald Pelican restaurant, a mini-mall with Soundview Restaurant, and lastly a community center and the Missiles and More Museum. (Courtesy of Paul and Susan Magnabosco.)

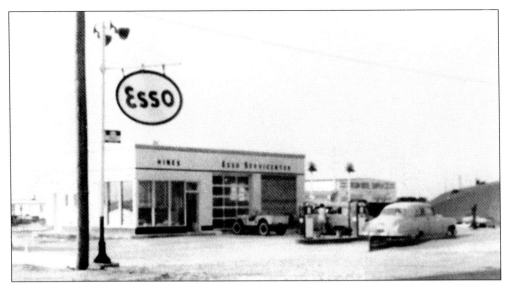

The Esso gas and service station was located on South Anderson Boulevard in Topsail Beach, but it is no longer there. Over the years, a variety of businesses have come and gone on the island, some due to storm damage, others because of how difficult it is to run a business during the off-season when the population drops considerably without the tourists. (Courtesy of Paul and Susan Magnabosco.)

The first general store was the New Topsail Market, located at the corner of Flake Street and South Anderson Boulevard. The James Averon Godwin family has been involved with the business, first as managers, then as owners. Still owned and operated by the Godwin family, the store has remained virtually unchanged in appearance since it opened in 1949. (Courtesy of Paul and Susan Magnabosco.)

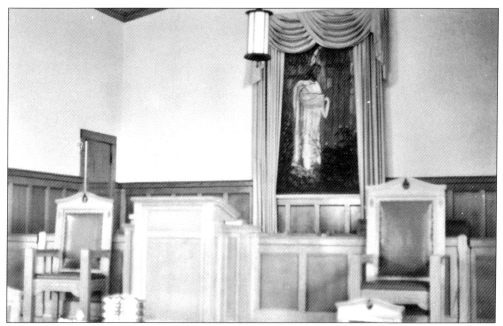

In 1953, the visiting minister Rev. Barney Davidson of Fayetteville worked into the night and surprised the congregation with a large painting of Christ, some say to cover the window behind the pulpit that often caused an unpleasant glare. Hurricane Hazel took off the roof, but the painting was left unharmed. Shown here in its original location, the painting was later moved to the back wall after renovations. (Courtesy of Julia Barnes Sherron.)

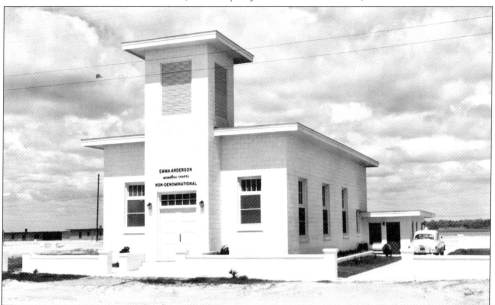

The Emma Anderson Memorial Chapel was originally funded through the efforts of developer J. G. Anderson Sr., who offered lots to buyers with the stipulation that they pay 10 percent of the purchase price to the "Church Fund." The IRS eventually ruled that the policy would not be allowed, but the church was built and has thrived. (Courtesy of Phil Stevens and the Wayne Reynolds family.)

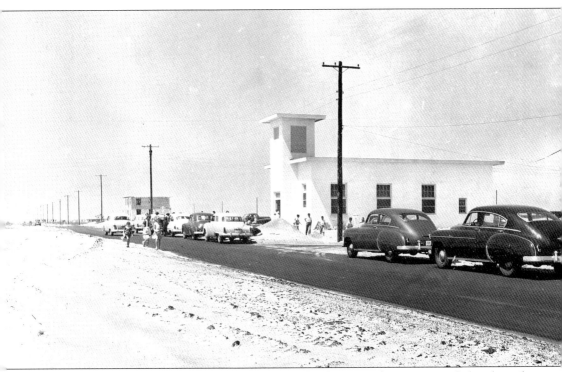

The Emma Anderson Memorial Chapel was designed to be a non-denominational church, and true to its origins, it remains so today. Originally the plan was to have a different property owner sponsor a visiting minister each week during the summer season when the church held services. The sponsor would also clean the church, provide fresh flowers and ushers, and perform any other duties necessary to prepare for the service. Visiting ministers were allowed free use of a cottage for the week and in return were expected to give the sermon—hopefully their best—on Sunday morning. The chapel serves a unique ministry to the ministers by providing them time to relax and rejuvenate. Over the years, the church has grown, not only with the physical expansion in the 1990s, but also with expanded year-round services, offering two services each Sunday morning during the summer to fill the needs of vacationers and summer residents. Congregants still sponsor ministers, but they no longer have to perform all of the other duties. (Courtesy of Phil Stevens and the Wayne Reynolds family.)

Well-known businessman Lewis Orr ran a real-estate office out of this building. Orr served as the first Topsail Beach mayor in 1963 and again in 1974. The white pillar and its mate on the other side of South Anderson marked the entrance to town. Each pillar had a welcoming light on it. The switches were in the Anderson's Realty Office a block away. (Courtesy of Paul and Susan Magnabosco.)

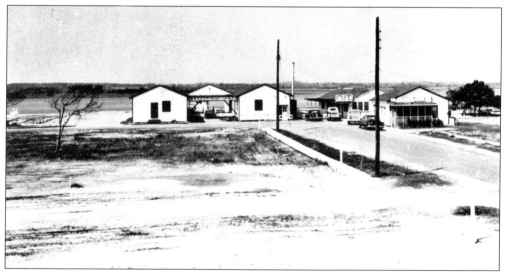

This view of the Breez-way Inn and Café shows how undeveloped the "downtown" area of Topsail Beach still was in the 1950s. Notice that boardwalks and street markers were installed. The army's mess hall and barracks from Operation Bumblebee became the island's first motel. It got the name because there was always a breeze rocking the chairs on the porch between the two buildings. (Courtesy of Dr. and Mrs. Howard Braxton.)

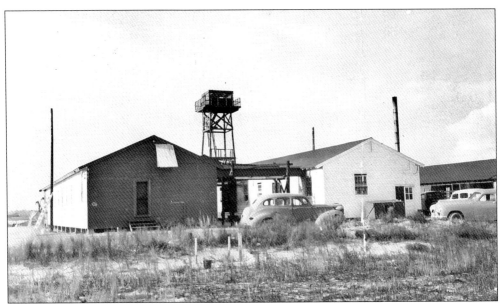

The Breez-Way Inn and Café was originally owned by New Topsail Beach developer J. G. Anderson Sr. Waitus Bordeaux and his wife ran the establishment from 1949 to 1950, after which Eunice Justice took over as manager and cook in 1951. Her husband, Dewey, served as town councilman for four years and was mayor from 1967 to 1968. (Courtesy of Phil Stevens and the Wayne Reynolds family.)

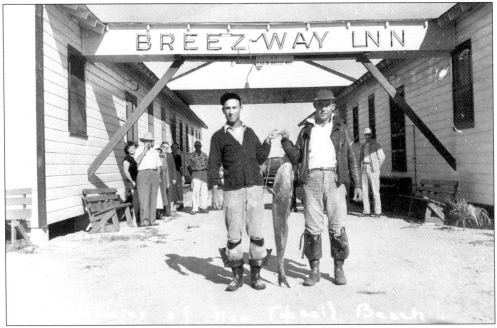

After managing the establishment for a year, Eunice Justice and her husband, Dewey, traded their oyster business and home for the Breez-Way Inn and Café. They continued to run the place until they sold out in 1972 to Dr. M. L. Cherry. William ("Bill") and Kathryn Merrit ("Kathy") Cherry own and operate the businesses today, now called the Breezeway Restaurant and Motel. (Courtesy of Phil Stevens and the Wayne Reynolds family.)

This 1950s view shows the Florida Motel and Apartments, a low-slung string of rooms and apartments that proved to be popular to families and fishermen alike because of its close proximity to the ocean pier and beach. Rooms were named after Florida towns. When the property was recently cleared for development, the original white pillar marking the town's entrance was left intact. (Courtesy of Phil Stevens and Wayne Reynolds family.)

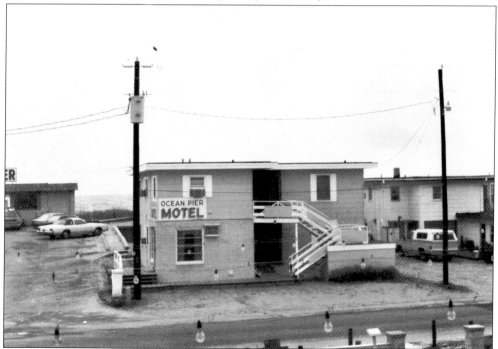

The Ocean Pier Motel, located right next to the Jolly Roger Pier across the street from the Patio Playground, was originally owned by Clarence Smith. Lewis Orr built and also ran it for a time. The Ocean Pier Inn was recently torn down, and duplexes have been built on the site. (Courtesy of Charles Hux.)

Twenty-five years makes a lot of difference in how much areas have built up on the island. This view was taken from Whitecaps condominiums in Topsail Beach facing the sound. Today the view is quite different, with buildings filling many of the empty lots and others being enlarged or replaced. (Courtesy of Charles Hux.)

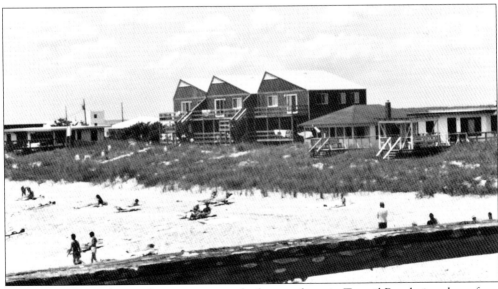

Whitecaps is a popular condominium project built second row in Topsail Beach, just down from the Jolly Roger Pier and the hub of town. In beach real-estate terms, second row means the second row back and across the street from the ocean or sound. The distinctive architecture of the building stood out in this early beach photograph, possibly taken from the pier. (Courtesy of Charles Hux.)

Former owner Charles Hux took this shot of the Patio Playground in the 1980s. The entertainment complex occupies a second-row parcel between Ocean Boulevard and South Anderson Boulevard right across from the Jolly Roger Pier. For decades, kids of all ages have enjoyed a variety of offerings, including miniature golf, air-conditioned arcades, concessions, a picnic area, a kiddie pony, and a photo booth. (Courtesy of Charles Hux.)

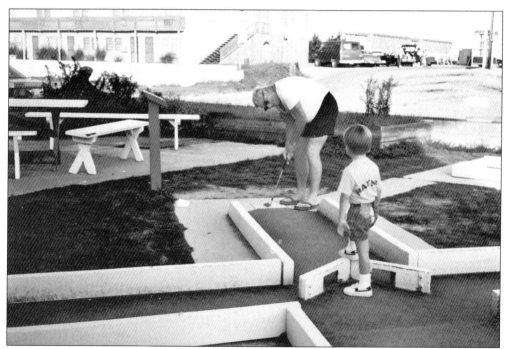

Haynes Sherron and his grandfather Jack Barnes shared a round of miniature golf at the Patio Playground. This putt-putt course has entertained families of summer residents and vacationers for generations. During the summer, youth groups from the Emma Anderson Chapel gathered weekly at the complex for golf and fellowship, and they still do. (Courtesy of Julia Barnes Sherron.)

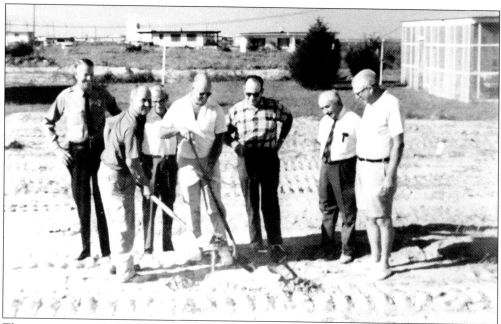

The community rallied behind the Volunteer Rescue Squad as evidenced in this groundbreaking ceremony for the Volunteer Rescue Squad and Fire Department building. Participating in the early 1970s event are, from left to right, police chief Fred Dickerson, town commissioner J. A. Godwin, Ed Warren, Floyd Stewart, Forest McCullen, Mayor Michael A. Boryk, and Doug Sunderland. (Courtesy of Merle Morris.)

Norman Chambliss Jr. donated the use of his old International Scout to get the Volunteer Rescue Squad started. His son Norman Chambliss III was one of the high school and college students who provided the manpower, and Marrow Smith was the first chief. The Ogden Rescue Squad sold the group a 1957 Cadillac ambulance and assisted in training. (Courtesy of Paul and Susan Magnabosco.)

One of the oldest piers on the island, the Topsail Sound Pier was built in the 1950s as an attraction to help promote the J. G. Anderson development. Constructed by Slim Anderson, the pier had early operators including Charles Gaskins and the Mullens family. Michael Andrew Boryk bought the pier in 1960. The building pictured here was built in 1969. (Courtesy of the Oppegaard family.)

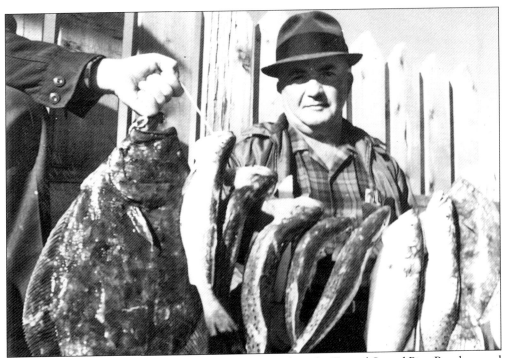

Michael Andrew Boryk is shown here with a great catch at the Topsail Sound Pier. Boryk served as Topsail Beach mayor from 1968 to 1973 and again from 1976 until his death in 1980. Phil Stevens was appointed to serve the rest of his term. During his tenure, Boryk received funding for the town's first well and constructed the first town hall. (Courtesy of Oppegaard family.)

Anna Gmytruk Boryk and her husband, Michael Andrew Boryk, are shown here with a friend enjoying the beach. Michael farmed 500 acres of fruit and vegetables in Burgaw, making him one of the largest growers in North Carolina. He invested in real estate, purchasing island property including the Topsail Sound Pier. A key to his success was to be personally involved, which was the case with the pier until 1970, when his daughter Amelia Annette Boryk Oppegaard and her husband, Milton ("Kip") Oppegaard, took over the pier after moving permanently to Topsail from Virginia. The entire family believes in community involvement. Kip was a member of the first fire department, was once chief of the rescue squad, and served as a Topsail Beach town commissioner from 1975 to 1981 and as mayor from 1983 to 1999. Annette was honored as the first Topsail Area Chamber of Commerce Woman of the Year. Their son Michael Rae Oppegaard was an Eagle Scout, and daughter Michelle Oppegaard Weaver earned the Silver and Gold Awards in Girl Scouts. (Courtesy of the Oppegaard family.)

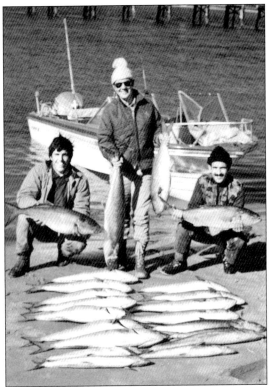

Fishing has always been a popular island sport, but when the fishing is good, life is great. In 1974, with a storm brewing, from left to right, Paul Magnabosco, his cousin Bo Warren, and their friend Dan Mann went fishing in a 16-foot outboard motorboat. Their catch included a 26-pound king mackerel, 14 bluefish, and several small king mackerels. Now that was a good day. (Courtesy of Paul and Susan Magnabosco.)

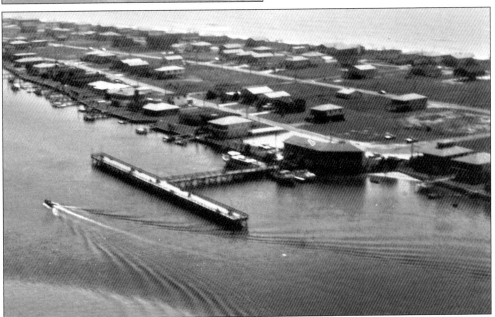

The Topsail Sound Pier was the last pier located on the south end of the island. Early in the pier's history, islander Harvey Jones drove out onto the end of the pier to kick off large-scale motorboat races in which participants came from far and wide to compete. People watched from private docks and decks along the shoreline to see the competitive boats race. (Courtesy of Dr. and Mrs. Howard Braxton.)

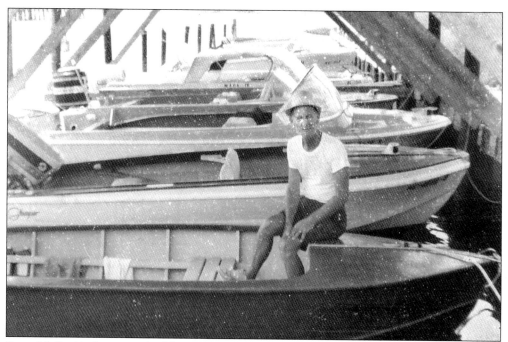

Steve Mallard is shown on the "Green Boat," as it was affectionately called. Built by H. Sanderson in 1955, the boat was docked at the Topsail Motel boat basin. The Topsail Motel still sits on the same site on South Anderson Boulevard, but the marina and boat dockage are no longer there. (Courtesy of Dr. and Mrs. Howard Braxton.)

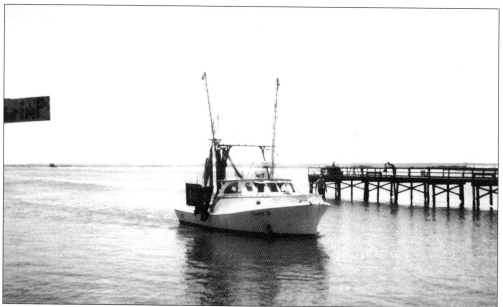

Sailing from the Sound Pier, Dolphus Thompson shrimped these waters for decades, selling fresh shrimp from his boat at the end of the day. He put five children through school with his shrimping. Dolphus was much loved by the islanders. When his boat caught fire and burned to the waterline, the community gathered to help with a barbeque chicken benefit. (Courtesy of Dr. and Mrs. Howard Braxton.)

Warren's Soda Shop was the first fountain to open on the island in the early 1950s. Warren's original location was at the corner of Crews Avenue and South Anderson. In 1959, they moved to Davis Avenue. About the same time, the first streetlights were installed, paid for by private residents. Show here is one of the lights in front of the second Warren's location. (Courtesy of Paul and Susan Magnabosco.)

"Where Friends Meet" was the motto for Warren's Soda Shop, and that held true for vacationers and residents alike. Shown here are teenagers having fun the way so many did during the soda-shop era. Warren's is now the Beach Shop and Grill, owned and operated by Jeff and Cheryl Price, still a great place to meet and greet friends old and new. (Courtesy of Paul and Susan Magnabosco.)

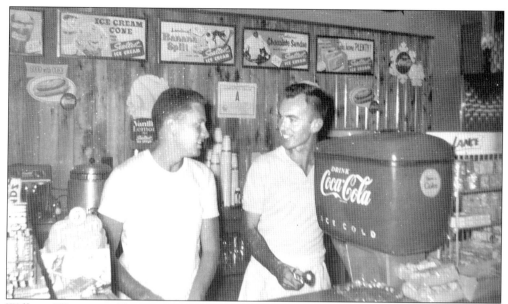

William Warren and his sister Rachel Warren Magnabosco were the owners and operators of Warren's Soda Shop. Warren (right) is shown here with Emory Sadler, who—like so many teenagers whose families had summer homes here—worked and hung out at the popular soda shop. (Courtesy of Paul and Susan Magnabosco.)

The camaraderie of the soda shop teenagers is legendary. Since they could not be together at Christmas, the owners gave a big end-of-the-season Christmas party for the employees at Rachel Magnabosco's home, complete with decorations and a Christmas tree that could be seen from the sound, causing considerable interest since it was summertime. The hosts were, from left to right, William Warren and Rachel and Paul Magnabosco. (Courtesy of Paul and Susan Magnabosco.)

The Sea Vista Motel is the last oceanfront motel on the south end of the island. In August 1981, the motel was converted into the island's first motelomenium. Each room is privately owned and decorated accordingly, but the property as a whole is managed like a motel with rooms available by the night or the week or longer. (Courtesy of Martha Alexander.)

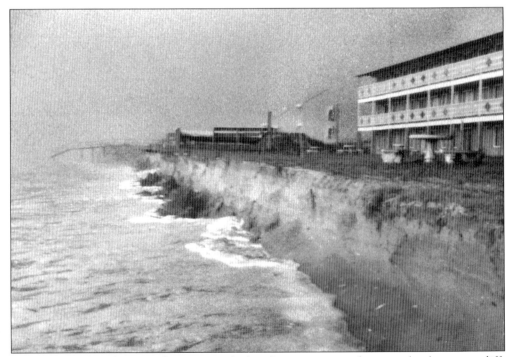

Hurricanes and northeasters chew away at the beach, causing coastal erosion that leaves sea cliffs like these, called escarpments. This photograph was taken in November 1978 showing a line of oceanfront houses south of Sea Vista that no longer exists, along with the ground-floor rooms of the motel. (Courtesy of Dr. and Mrs. Howard Braxton.)

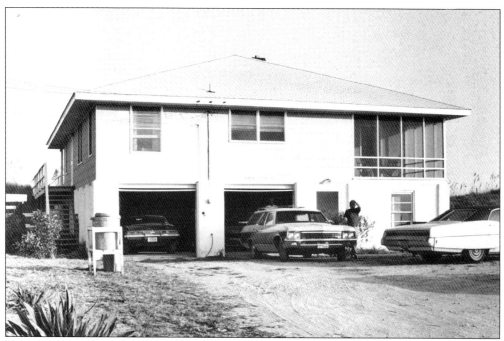

Longtime homeowner Norman Chambliss Jr. is a great example of someone who wet his feet in the Topsail market by purchasing one home with another family, only to eventually decide to buy his own home two doors down. Both homes have survived decades of storms and development, and his second home, shown here, can be recognized in Topsail today. (Courtesy of Nancy and Norman Chambliss Jr.)

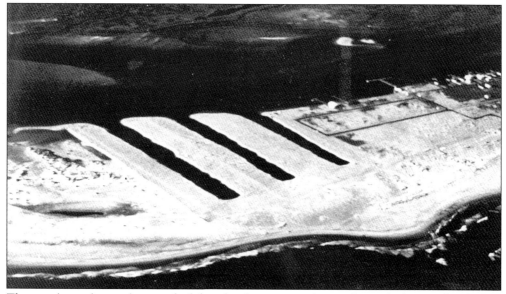

The canals on the southern end of the island are extremely popular with the people who live there. The lots are so hard to come by that some homeowners resort to moving their old homes off site to make room for building new houses. Here is an early view of the canals, probably from the 1970s. Today houses fill every lot, and docks are plentiful. (Courtesy of the Oppegaard family.)

This is the first large boat—a bathtub boat—built in the 1950s by the Jones brothers, Donnie (in the boat) and Robert (beside the dock) of Jones Brothers Marine, at their family's second home on Topsail Island. Boat-building interests apparently ran in the family. Their father and uncle built the boat on page 53 that was thrown into their dock during Hurricane Hazel. (Courtesy of Marianne Jones Orr and family.)

The families who built on the island in the 1940s gave their children a unique experience, since virtually nothing was here but the remnants of Operation Bumblebee and the beginnings of what would become Topsail Beach and Surf City. Sitting on their beach jeep are, from left to right, Marianne Jones Orr, Jennifer Jones Rippy, Donnie H. Jones III, and Robert Alan Jones. (Courtesy of Marianne Jones Orr and family.)

This was the second boat the Jones brothers built, an interest they took with them into adulthood. For years, they sold aluminum johnboats at their store near Morehead City. Then in 1989, Jones Brothers Marine launched their first "bateau"—a tough fiberglass johnboat—the first of many other successful boats to come and a long way from that first bathtub boat built on Topsail. (Courtesy of Marianne Jones Orr and family.)

When someone hooked themselves fishing or needed medical attention and Dr. Donnie H. Jones Jr. was on the island, people would go to his house for treatment. Shown here are Dr. Jones and his wife, Nancy, across from their sound-front home, built in 1949 and one of the few houses left standing after Hazel. The former Hedgecocks Building Supply is visible to the right. (Courtesy of Marianne Jones Orr and family.)

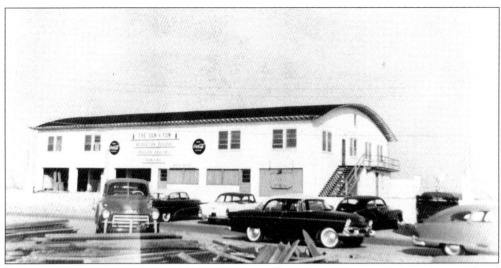

Slim Anderson, J. G. Anderson's son, built onto and converted the missile launching pad and bomb room building into the Sun N Fun Recreation Hall, which included a post office, skating rink, arcade, and trampoline area. Many locals fondly recall evenings of skating until around 10:00 p.m., when the rink closed and the dancing began. (Courtesy of Paul and Susan Magnabosco.)

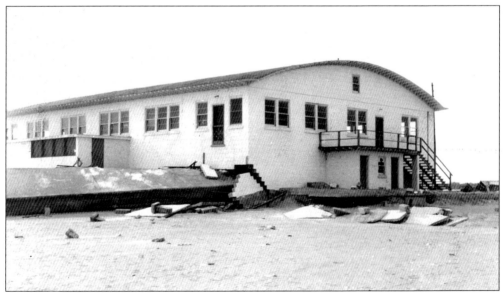

Some longtime residents swear they played in a leftover Bumblebee tunnel. Others are just as adamant that one never existed. Still others say the rumor started from a large conduit that housed wires running from the Assembly Building to the launching pad. Hazel revealed a "tunnel" that appears to support the last theory, but one thing is clear—neither side seems to be swayed. (Courtesy of Phil Stevens and the Wayne Reynolds family.)

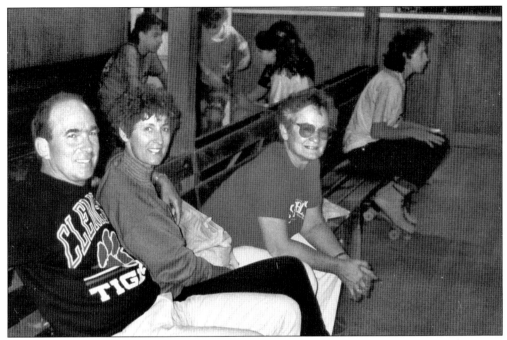

A new skating rink was built on Anderson Boulevard by Sonny Jenkins and his wife, Doris, who still plays vintage 45s in the rink that has delighted vacationers since the 1960s. Old pews from the Surf City Baptist Church are used for seating, with the inscriptions still on the back. Seated from left to right are Jim and Betty Marlin with her sister, Jo Anne Paulin. (Courtesy of Jo Anne Britt Paulin.)

Below the skating rink is the Topsail Beach Post Office, where Doris Jenkins has been postmistress for over 40 years, and Sonny (shown here) has a woodworking shop featuring a variety of birdhouses and cedar trunks. The Jenkins Skating Rink is an island institution, with its original wood floors, box fan "air-conditioning," and true island hospitality. It is still the place to go for fun on vacation. (Courtesy of Sonny and Doris Jenkins.)

In 1954, Lewis Orr built the New Topsail Ocean Pier, which was taken out by Hazel and later rebuilt. In 1966, he bought the skating rink building and converted it into the Jolly Roger Motel, which he expanded in the late 1970s, making it the largest motel in Pender County. The pier was renamed the Jolly Roger Pier, and Lewis's son Robin Orr now runs it. (Courtesy of Larilyn Swanson.)

Fun at the beach is what Topsail is all about. The Pleasant sisters have been celebrating "Sister Week" together once a year in Topsail Beach at the Barnes family home for decades. The group includes seven sisters and three sisters-in-law. Wearing some fabulous sun hats are, from left to right, Rachael Peterson, Billie Lassiter, and Sue Ogburn. (Courtesy of Julia Barnes Sherron.)

Nine

ľH TOPSAIL BEACH
ɒ SNEADS FERRY

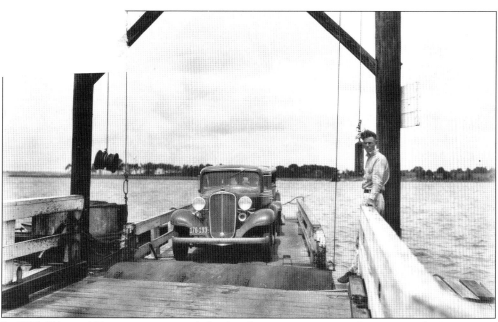

In 1725, Edmund Ennett was granted the first license to operate a ferry across the New River in what is now Sneads Ferry, providing an important connection in postal delivery between Virginia and South Carolina. Originally known as Lower Ferry, it was renamed Sneads Ferry in 1760 in honor of the new ferry operator, attorney Robert Snead. A controversial character, Snead shot and killed Revolutionary War hero Col. George W. Mitchell in 1791. He was tried and convicted of the murder but then received a full pardon from Gov. Richard Dobbs Spaight. Speculation was that Snead used his political connections to receive the pardon. Shown here in 1938 is the Sneads Ferry and operator Jack Prescott. (Courtesy of Onslow County Museum, Richlands, North Carolina.)

The village of Sneads Ferry, located on the New River, was settled around 1775, making it the oldest established community in Onslow County, which itself was established in 1734, making it one of the oldest counties in North Carolina. The ferry, shown here in 1938, was a key part of the community until 1939, when it was replaced by a wooden bridge. (Courtesy of Onslow County Museum, Richlands, North Carolina.)

As old as Sneads Ferry is, Fulchers Landing is the oldest settlement in Sneads Ferry. Shown in the 1930s, these travelers might have been stocking up on supplies. The New River is one of the few rivers of any size in the United States that flows almost due south. (Courtesy of Onslow County Museum, Richlands, North Carolina.)

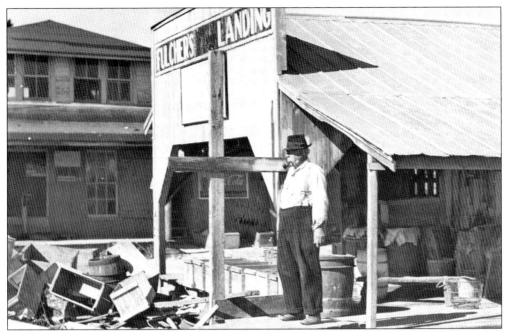

Boat landings and fish houses, stores, and restaurants gradually filled the waterfront area near where the Green Turtle, Pirates Cove, and Riverview restaurants are today. This photograph shows a built-up area of commerce from 1938 in Fulchers Landing. Across the way was the village of Marine, named for the Marine family who had been there for generations. (Courtesy of Onslow County Museum, Richlands, North Carolina.)

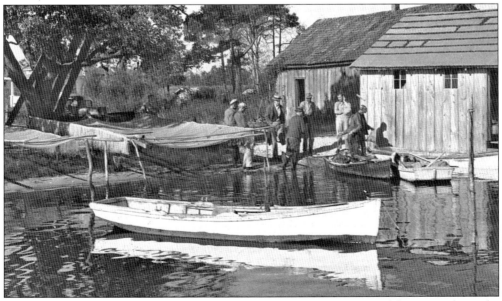

The story goes that Joe Fulcher started the first restaurant, and so many Fulchers moved into the area it became know as Fulchers Landing, with many stores built right at water's edge, like the one shown here in 1938. In 1946, Riverview became the second restaurant established. Sitting on the waterfront next to Everett's Seafood, Riverview continues to be a much-loved local tradition. (Courtesy of Onslow County Museum, Richlands, North Carolina.)

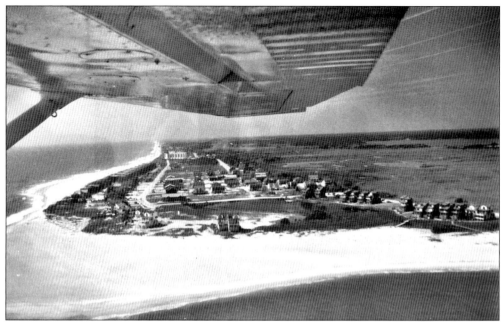

North Topsail Beach is located completely in Onslow County and covers almost half of the island's land area. Originally known as West Onslow Beach, the area at the far northern end of the island in present-day North Topsail Beach was called North Topsail Shores. At the end of the road, literally, is New River Inlet. (Courtesy of Bev Green.)

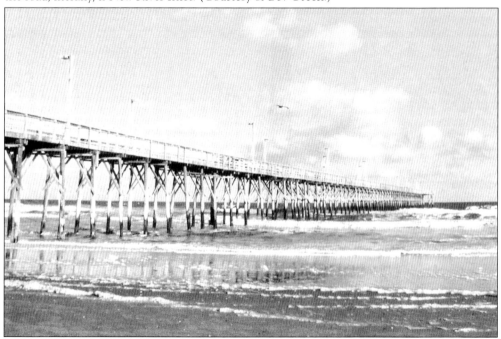

On the northern end of the island lies Topsail's newest pier, completed in 1999. The 1,000-foot-long ocean fishing pier is in a quiet area of the island. The pier shop offers bait and tackle, snack foods, and ice, and next door is the Sea View Motel. The Sea View is the only pier in North Topsail and the closest one to the high-rise bridge. (Courtesy of Bev Green.)

Brig. Gen. Wallace M. Greene Jr., base commander, discusses the individual clothing issued to each Marine with Wilmington visitors on November 22, 1957. They are, from left to right, J. E. L. Wade, mayor of Wilmington, Brigadier General Greene, E. L. White, A. E. Jones, Claude L. Efird, and Marine corporal M. J. Cozloff of Marine Corps Supply Schools, Marine Corps Base in Camp Lejeune, North Carolina. (Courtesy of Onslow County Museum., Richlands, North Carolina.)

Construction of Camp Lejeune, and before that Camp Davis, brought in thousands of craftsmen, workers, and troops to the area. During World War II, residents of Onslow and Pender Counties felt the strong presence of the military with large numbers stationed here. Along with the rest of America, people pitched in with victory gardens, air-raid drills, and v-mail. (Courtesy of Onslow County Museum, Richlands, North Carolina.)

This MV-22B Osprey is a common sight because of Topsail's close proximity to Camp Lejeune and Marine Corps Air Station, New River. This tilt-rotor aircraft is carrying a Humvee externally through the air, a sight that fascinates visitors and locals. The beauty of the Osprey is that it operates as a helicopter for takeoff and landing, but once airborne, it is a high-speed, high-altitude turbo-prop aircraft. (Courtesy of Bev Green.)

An osprey of the living, breathing kind, this bird grows to have a wingspread of five feet or more, eating a diet mostly of fish. They mate for life and share responsibilities like egg sitting or bird sitting of their young. This nest is atop a daymark, a navigational aid used to mark the edges of safe water areas in channels. (Courtesy of Missiles and More Museum.)

Topsail Island is tucked below Camp Lejeune Marine Base midway between Cape Lookout and Cape Fear, so Onslow Bay and other areas near the island are often use for Marine Corps maneuvers. This Landing Ship Dock (LSD) transports and launches amphibious craft and vehicles with their crews in amphibious assault operations and supports landings of conventional landing craft and helicopters. (Courtesy of Bev Green.)

Camp Lejeune makes for an interesting neighbor. On and off the marine base, it is not uncommon to see all kinds of military vehicles. This LVTP7, or AmTrac, is an armored assault amphibious full-tracked landing vehicle, which carries troops in water operations from ship to shore, even through the surf and rough water. (Courtesy of Bev Green.)

An oysterman scoops up oysters from beds usually located in the shallow water near the shore's edge. Fullard Creek, which flows into Chadwick Bay, is a nursery area for shrimp and oysters. This conservation effort will hopefully help supply shrimp and oysters for generations to come. (Courtesy of Bev Green.)

Oysters were once plentiful in the area. For a time, the New River oyster was considered to be one of the finest. Investors from Onslow County, Wilmington, and Raleigh formed the New River Oyster Company in 1891. Numerous oyster gardens were developed, but storm damage, over-harvesting, and dredging reduced the once-teeming oyster population, and the oyster industry declined. (Courtesy of Onslow County Museum, Richlands, North Carolina.)

It is common nowadays to see Hummers on the road, but this is the real thing, a former military humvee or HMMWV (High-Mobility Multipurpose Wheeled Vehicle) that has found a new life with the North Topsail Beach Police Department. The humvees are designed for all weather conditions and are used on all types of roads and difficult terrain. (Courtesy of Bev Green.)

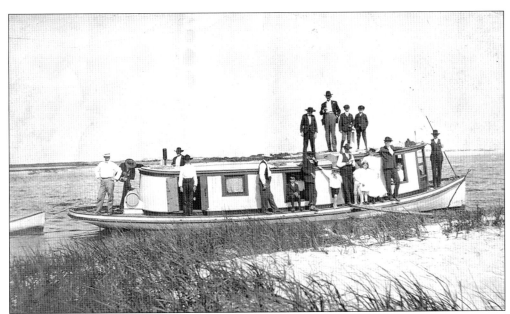

Taken in the 1920s somewhere on the New River, this photograph shows an outing that was probably a banks party, where one or several boats anchored or went ashore together for the purpose of a grand picnic. Some boats met regularly for banks parties, coming from different places. Often fish and oysters were roasted while people sang or danced to fiddle or harmonica music and children played. (Courtesy of Onslow County Museum, Richlands, North Carolina.)

Crab pots are tagged to show ownership. Inside the wire-frame crab pot is a V-shaped envelope bait holder filled with fish heads or raw chicken necks. The crabber checks the pots in a few hours, empties the crabs onto a sorting tray or bucket, and then sorts them according to sex, keeping the males or "jimmies" and releasing the females so that they will reproduce. (Courtesy of Bev Green.)

The recipe for square dancing is simple: you need four couples to make a square, a caller, and a little music. The fancy attire shown here is optional but seems to add to the fun. These dancers are at the Sneads Ferry Community Center, but classes and dances have been held in town halls, schools, and other places throughout the Topsail area. (Courtesy of Bev Green.)

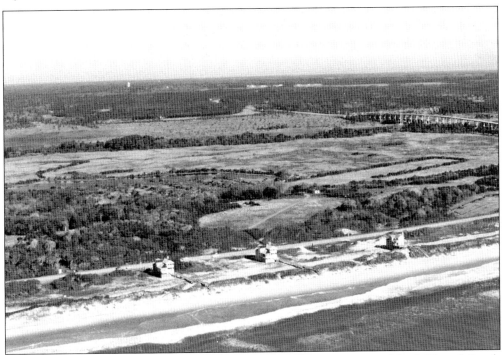

In this 1990s aerial view, a substantial portion of oceanfront property in North Topsail Beach between Surf City and the high-rise bridge was vacant, with only occasional houses dotting the landscape. Today building is booming in North Topsail, and the view is much different, with houses lining the beach and fewer vacant lots than ever before. (Courtesy of Bev Green.)

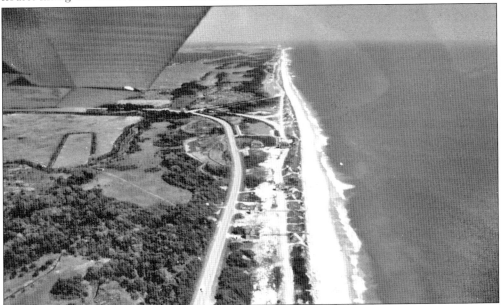

North Topsail Beach was the last of the island towns to incorporate in 1990. The area was originally known as West Onslow Beach but is now called North Topsail Beach because of its location. The township of Stump Sound and the area known as Ocean City are now included in North Topsail Beach. In this aerial shot, Highway 210 parallels the beach. (Courtesy of Bev Green.)

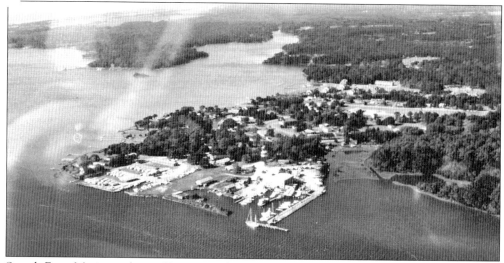

Sneads Ferry Marina welcomed boaters and campers for decades. Jill and Jerry Hinnant, the last owners, recently sold to a Charlotte-based developer who plans to build a gated community on the former ferry site on the New River. The New River is the only river in the continental United States with headwaters and mouth in the same county. (Courtesy of Bev Green.)

The Topsail Island/Surf City Airport was opened in 1982 by Les Garrison, Gene Gunter, and Wilbur Jackson. The turf runway that was once farmland was converted into a landing strip using a road grader. Gunter, a retired U.S. Air Force lieutenant colonel, also operated Topsail Scenic Flights. In recent years, both the airport and flying tours business have closed. (Courtesy of Bev Green.)

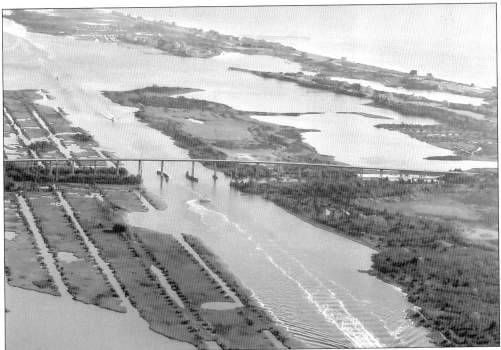

The U.S. Congress authorized the creation of the Atlantic Intracoastal Waterway (AIW) in 1919. North Carolina's segment was begun in 1927 with the Rivers and Harbors Act. The Beaufort-to-Wilmington section was completed in 1932. This aerial shot shows the waterway, the high-rise bridge, and the Atlantic Ocean in a breathtaking shot. (Courtesy of Traci and Dan Hackman.)

It is fairly common to see deer swimming in the shallow waters between the island and the mainland at dusk. Not as commonly, they sometimes wander onto the beach for a swim, which can prove dangerous because of the currents, waves, and possibility that the deer will swim out too far into the ocean to return. (Courtesy of Bev Green.)

Each year in August, Sneads Ferry honors area fishermen who make a living working the local waters by holding a huge celebration, the Sneads Ferry Shrimp Festival. Shown here is the 1993 Tiny Miss Shrimp pageant winner, four-year-old Kristi Medlin, daughter of Dan and Julie Medlin. Today the pageant competition includes the titles of Miss Shrimp, Junior Miss Shrimp, and Little Miss Shrimp. (Courtesy of the Medlin family.)

For over 35 years, the Sneads Ferry Shrimp Festival has been a huge community event with plenty of big-name and local bands, dancing, arts and crafts, a parade, food, and lots to do with shrimp besides eating them, including contests for shrimp heading, peeling, and cooking. Shown here is a 1958 photograph of a Shrimp Festival court. (Courtesy of the Medlin family.)

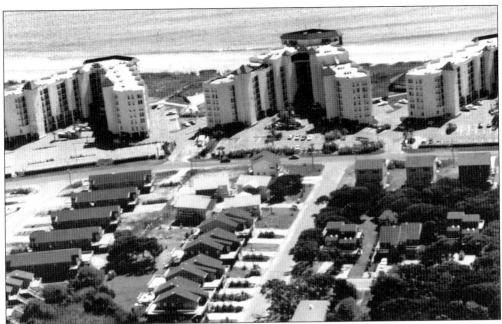

The St. Regis Resort and Conference Center was built as an all-suite luxury resort with amenities including pools, tennis courts, a fitness center, chip and putting green, specialty retail shops, game room, and restaurants. Over the years, the resort has made changes and repairs, but the three distinctive red-tiled towers are still inviting to visitors and residents of one of the largest resorts on the entire island. (Courtesy of Bev Green.)

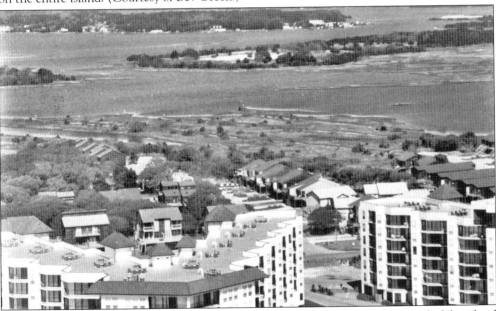

Splendid isolation and sparse population made Sneads Ferry and the northern end of the island desirable destinations for people seeking land grants in the early days of the area's development. Many came from Maryland, Virginia, and northeastern North Carolina, just as they do today. Even though both areas have grown considerably over time, each has kept its charm and individual personality. (Courtesy of Bev Green.)

Near Stump Sound off the coast of Topsail is Permuda Island, the site of seasonal encampments by Native Americans as early as 300 BC and a local trade center during Colonial times. The fight to preserve the island from development brought Walter Cronkite to the area. The original bridge was burned during the controversy but was built back and later destroyed again by a storm. (Courtesy of Dan Hackman.)

Since 1987, Permuda Island was declared a protected site managed by the Coastal Reserve and owned by the State of North Carolina. Permuda is a natural wonder perfect for exploring. Accessible only by water, the island is covered by a dense shell midden filled with archeological riches. (Courtesy of Dan Hackman.)

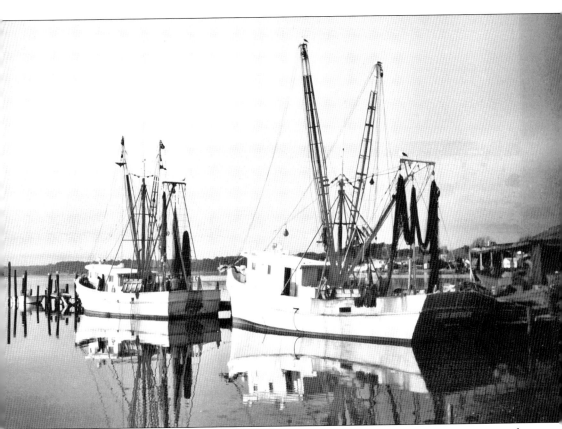

It is hard to imagine, but until the Civil War, farming was the area's main occupation, with farmers moving livestock across the shallow waters from the mainland to use the island as grazing land. The war brought different priorities, and the salt industry flourished. With a growing population, fishing finally became part of the fabric of our history. In the early 20th century, fish camps appeared, particularly during the fall, when residents would move to the beach to harvest mullet, which were salted and placed in barrels to sell. This led to year-round commercial fishing, which continues today. Sneads Ferry annually catches over 385 tons of shrimp, 25 tons of flounder, and approximately 493 tons of other delicious seafood like clams, scallops, oysters, mullet, spots, grouper, crabs, and sea bass, according to the 2005 information from the North Carolina Fisheries Association. Shown is an example of the area's many shrimp boats docked in Sneads Ferry. (Courtesy of Bev Green.)

ACROSS AMERICA, PEOPLE ARE DISCOVERING SOMETHING WONDERFUL. THEIR HERITAGE.

Arcadia Publishing is the leading local history publisher in the United States. With more than 3,000 titles in print and hundreds of new titles released every year, Arcadia has extensive specialized experience chronicling the history of communities and celebrating America's hidden stories, bringing to life the people, places, and events from the past. To discover the history of other communities across the nation, please visit:

www.arcadiapublishing.com

Customized search tools allow you to find regional history books about the town where you grew up, the cities where your friends and family live, the town where your parents met, or even that retirement spot you've been dreaming about.